T A T T O O

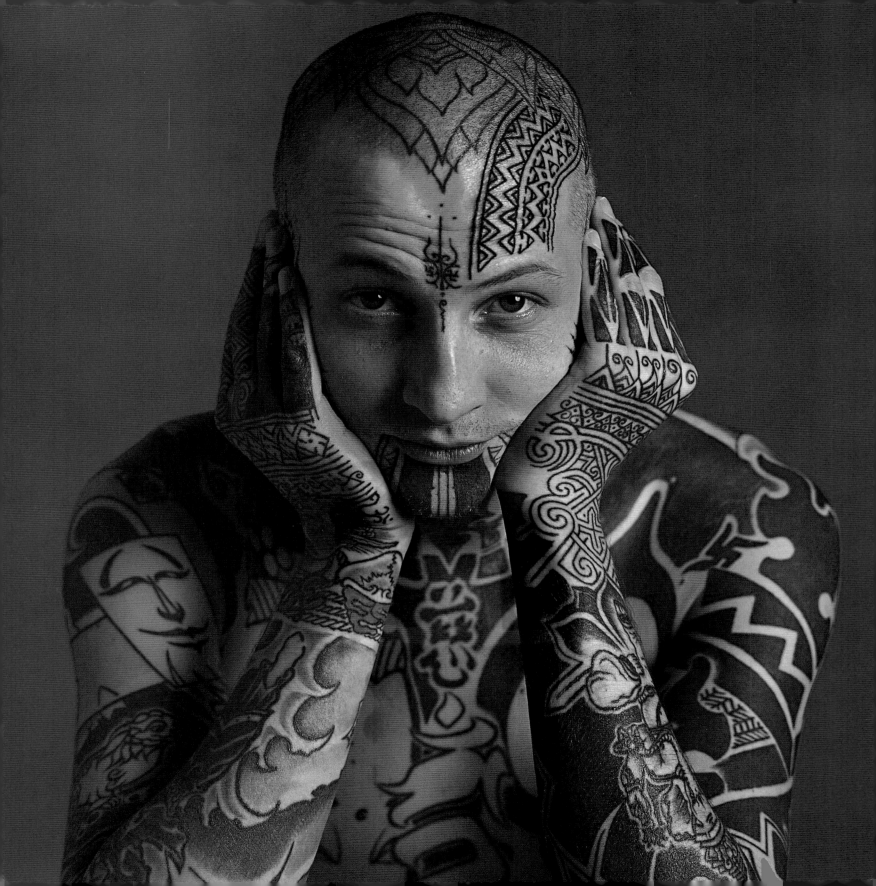

TATTOO

Photographs

by

Dale Durfee

St Martin's Griffin
New York
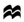

To Mom and Dad

Library of Congress Cataloging-in-Publication Data available on request

ISBN 0-312-26784-3

First St Martin's Edition 2000

1 3 5 7 9 10 8 6 4 2

AN EDDISON•SADD EDITION
Edited, designed and produced by
Eddison Sadd Editions Limited
St Chad's House, 148 King's Cross Road
London WC1X 9DH

Phototypeset in Rotis Semi Serif using QuarkXPress on Apple Macintosh
Printed by C & C Offset Printing Ltd, Hong Kong

CONTENTS

FOREWORD

Photography is the way I choose to express myself and trying to capture the energy and the spirit of the models is very rewarding. In my professional life I have photographed people from every angle. In my personal work I keep coming back to the human figure, which most satisfies my imagination as a photographer and as a woman.

My involvement with tattooing began, when casting around for arresting images for an exhibition, I was excited by the idea of bodies decorated with fantastic designs.

I began contacting tattoo studios and magazines, finally meeting Mick Narborough, a tattoo artist. He was very positive about the project, and came charging round with five great guys in leathers. They stripped off to expose an astonishing variety of designs.

Working with them I became fascinated by body decoration and by the people who had them. Having the opportunity to work on this book I felt I needed to look at the whole picture. This resulted in a visit to the Dunstable Tattoo Expo, Bedfordshire, England, with cameras, canvas, lighting, two assistants, John and Karen, and the Art Director of this book, Elaine. The 1999 Expo was sadly to be the last in the

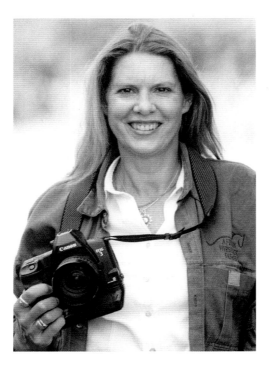

present venue, the institution having been started in 1986 by Ian of Reading, tattooist, and his crew. People from all over the Western world came together to talk about tattooing and piercing. Exhibited were the latest tools and dye colours and all the newest trends and designs. There were competitions, parties and a great buzz of comradeship.

I raced around inviting as many people as I could, whose designs I thought the most exciting and beautiful, to come and be photographed. To work with real people, without the fuss of stylists, hairdressers or make-up, coming to me with great naturalness, was an experience never to be forgotten. Through this I have come to respect and admire the people and their work and feel excited that this art form is coming into its own.

My hope is that TATTOO finally recognizes the skill of tattooing as an art form for our times.

Dale Durfee
London, 2000

6

OUT OF THE SHADOWS

It's not that long ago that Western eyes saw tattoos as a symbol of something barbaric and threatening, the preserve of 'lower' social class members, such as sailors or ex-cons. History tells us that, in reality, tattoos have little to do with barbarism, and are in fact the result of highly developed cultures. It is something of a well-kept secret that, even in the 1880s and early 1900s, members of European royalty and American high society sported tattoos: Queen Victoria's grandsons, Winston Churchill's mother, Princess Waldemar of Denmark, Emperor Wilhelm II, American socialites the Vanderbilts ...

No one is absolutely certain where the word 'tattoo' came from, but it may be derived from the Tahitian 'tatu', 'to strike'. History has it that Captain Cook brought the word back to the English-speaking world after his great voyages of the South Seas during the 1700s. Cook also brought many tales and drawings of tattooed people, causing a resurgence of interest in the art.

Evidence suggests that people all over the world have been tattooing their bodies for thousands of years, often as a way of showing their social status. The Neolithic 'Iceman' found preserved in ice in the Italian Alps during the early 1990s had tattoos on his back and legs. Recent theory suggests that these may be marks indicating points for acupuncture. Mummies preserved in the desert sands of Mongolia have beautifully tattooed hands. The Maori people have developed immensely intricate facial patterns that tell of the bearer's ancestry, life, and personality.

"When the designs are chosen with care, tattoos have a power and magic all their own. They decorate the body but they also enhance the soul. I encourage you to look deeply within yourself to find your tattoo design, to discover the real passions and pleasures that spark your life."

From 'Tattoo: The Exotic Art of Skin Decoration'
by Michelle Delio

Bedouin women have long worn facial tattoos to ward off evil. In India and Tibet, special tattoos mark momentous life-events such as puberty and marriage. Tattooing has been used to terrify warrior enemies, confer protection from disease and the power of evil spirits, show membership of some kind of group (good and bad), express the spirit of rebellion, and simply to enhance the body. French craftsmen once carried symbols of their trade in the form of tattoos – allowing them to travel widely and advertise their services, transcending the barriers of language.

The land of exquisitely ornate decoration, Japan, has a tradition of beautiful, multi-coloured tattoos, often worn to protect against harm or bestow strength in battle. Here, elaborate designs that flow over large areas of the body have long been a tradition. During the early part of this century, this was perhaps the only part of the world where such work was available. In parts of Africa, tattoos are seen as a traditional type of vaccination for women, as these small wounds are believed to strengthen the immune system and so protect the body from possible infection during pregnancy and childbirth.

In the West, the warlike Celts and Picts covered themselves with tattoos to chill the blood of any adversaries, but their enthusiasm for this body art was not continued on a wide scale in Europe. During the 1600s and 1700s, tattooed individuals from places such as Polynesia were often paraded around the homes of wealthy Europeans as curiosities.

Among Westerners, it seems that tattooing has only ever had a minority appeal – until relatively recently. The Christian church is thought to have banned tattooing at one point, but it may well be that the real reason behind the current acceptance of this art form is the Western obsession with change and fashion, a trend that has been growing ever since the Renaissance. In recent decades, more and more people in the West have been seeking out some stability, permanence and spiritual depth, leading to increasing respect for all kinds of so-called 'New Age' beliefs and practices and for the lifestyles of all traditional peoples the world over. Marry this search for permanence with the age-old desire for adornment and the very modern desire for unique forms of personal creative expression and ... you have the tattoo.

"Tattoos are more than skin deep, you know. That ink surfaces from your soul."

From 'Tattoo: The Exotic Art of Skin Decoration' by Michelle Delio

THE RE-AWAKENING

It seems that the recent Western movement for body decoration really started life in the California of the 1950s and '60s. Skilled tattoo artists found themselves travelling around the Pacific, where people had long worn extensive tattoos. They brought back to the States all kinds of ideas garnered from places such as Japan, Polynesia and New Zealand. Designs started down a very different path because the new emphasis was on creating tattoos that worked in harmony with the three-dimensional form of the human body, a startlingly different direction to take.

The 1960s has become known as a time of great personal freedom and individual expression. Revolution was in the air, and more flesh was exposed than within living memory. Tattooists began to share ideas and to see themselves as a band of skilled artists with

"There is no nation on Earth that does not know this phenomenon."

Nineteenth-century naturalist Charles Darwin on tattooing

something in common, not as strange backstreet denizens of a twilight world of gangsters and sailors. By the 1970s, the world of the tattoo was already a very different place, embraced by a range of people, of both sexes, and taken seriously in some quarters. Certain artists in body decoration became famed and sought after for their signature style. Designs were drawn freehand rather than being traced off a standard motif.

Time was when you walked into a tattoo parlour, scanned the images on offer on the walls, pointed to the design of your choice and hoped that this would somehow translate well to your body. Assorted patriotic symbols involving animals and flags, the name of a loved one (who would, hopefully, remain a loved one), or – when really pushing the artistic boat out – a heart or small rose, loomed large in the average tattooist's repertoire. The colour palette used was woefully narrow. Those days are long gone and now you can opt for something more special and personal, conceived either by a tattoo artist, by ourselves or in partnership with the tattooist. Garish back-street parlours have given way to more stylish high-street studios where the tattooist may well have been art-school trained and where advance appointments are required.

Tattooing is now, finally, emerging from the shadows into mainstream popular culture. Taken up increasingly by public figures, especially stars of film, fashion and rock, it is creeping into the psyche of all kinds of ordinary people. Only a very short while ago, tattoos were often worn as an act of rebellion. Today, they are more of a statement of people's interest in their bodies and in all forms of body decoration, in the aesthetics of skilled design, and in the spiritual, symbolic aspects of this amazing art form.

8

TAKING THE PLUNGE

So, for those of you out there who may be drawn towards body decoration for the first time, what can you expect? A certain aura of fear and mystery still surrounds the whole topic of tattoo studios. Today's methods are relatively quick and painless, using organic pigments and very fast, high-powered tools. The American-invented electric tattooing machine only came into being in the 1890s, before which practitioners used a sharp implement to pierce the skin and dispense pigment; some artists prefer manual methods today. The invention of the 1890s, updated in the late 1960s, remains essentially unchanged today.

The basic tattooing procedure is simple. The area in question is shaved and wiped over with antiseptic. Then one or more needles, attached to a rapidly moving electric device, are used to create the basic outline of the design. Excess ink is constantly wiped away. Multiple needles are then used to infill the design with different colours. A small tattoo might take just half an hour; choose a vast, complex design and it may take forty or more hours to complete.

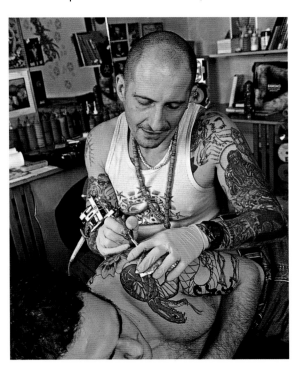
Tattoo artist Claudio

When the tattoo is done, the area gets a covering of antiseptic cream and a bandage. You'll be told how to look after it, which includes using a very rich cream to keep the skin supple. Most people feel much more comfortable after about twenty-four hours, and virtually no pain after a week. How much pain you feel depends on you, but many people experience very little. It is worth bearing in mind that some parts of the body are more sensitive than others. Sensitive areas such as the spine or ankle, where the bone is near the surface of the skin, might not be the best places to choose for your first foray into body decoration.

Treat your body with respect and be as careful as possible where body decoration is concerned. Spend time seeking out a tattoo artist whose work you admire, who really knows what they are doing, and who works in the cleanest possible conditions. Best of all, follow the recommendation of someone who has already been tattooed.

Times really have changed in the West as far as the creative content of tattoos goes. At the turn of the twentieth century, tattooists used sheets of standardized designs to save time and money. At the turn of the twenty-first century, people feel free to think about what expresses their personality and beliefs. They may use their own sketches and ideas and work with the tattoo artist to produce something that makes just the right kind of personal statement.

It is really worth taking time over finding the right image for you – the best kinds of tattoos are often those that are expressions of your soul, and not just superficial body ornaments. If you worry that time will fade the appeal of your tattoos, just turn your thinking around and view things as Michelle Delio does in her book, 'Tattoo: The Exotic Art of Skin Decoration'; as long as you thought long and hard about choosing your design, even if it doesn't express the current 'you', it will mark how you were 'then' – which has made you what you are today.

9

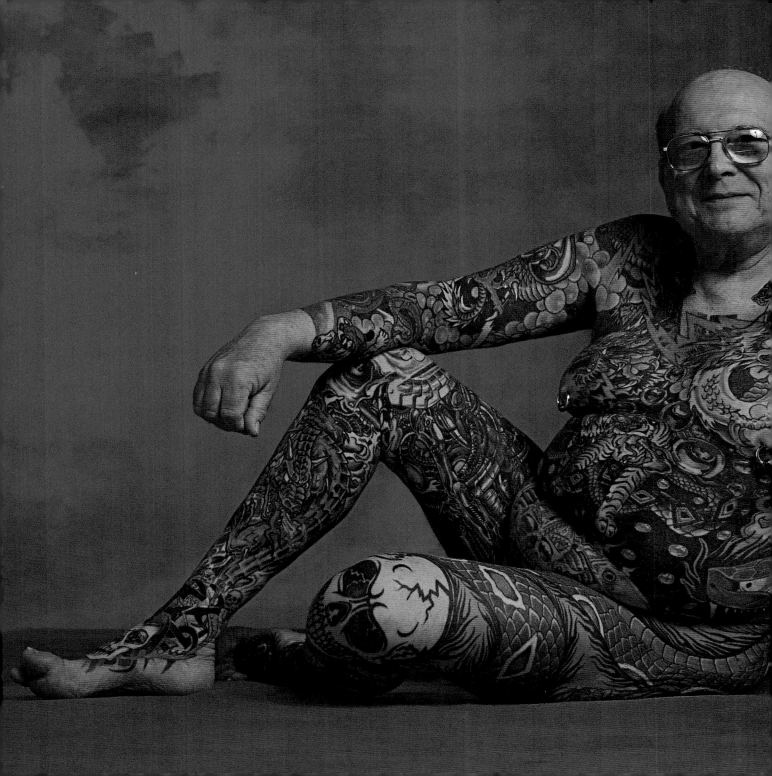

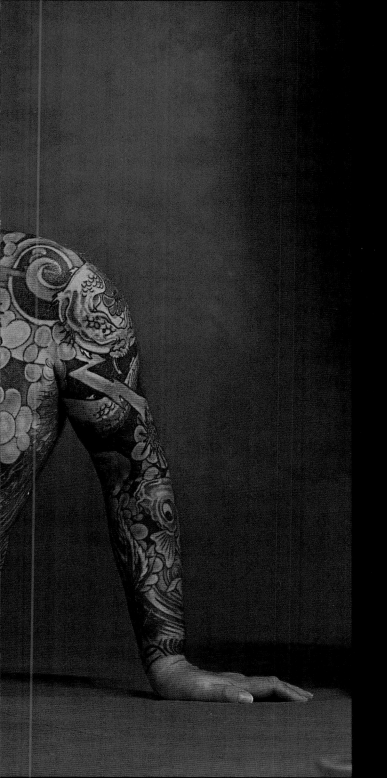

"I am a very shy, reticent person and my tattoos ma
me feel part of the community of tattooed people.
I love it!"

Larry

1 2

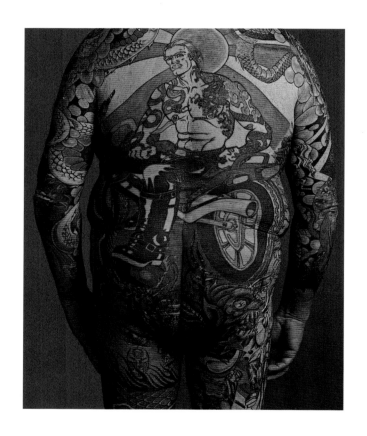 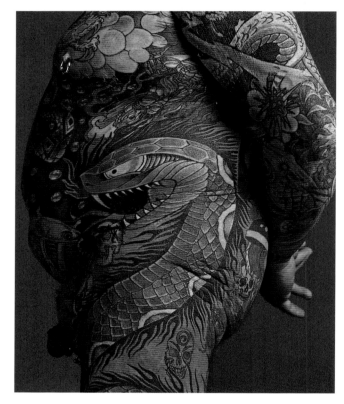

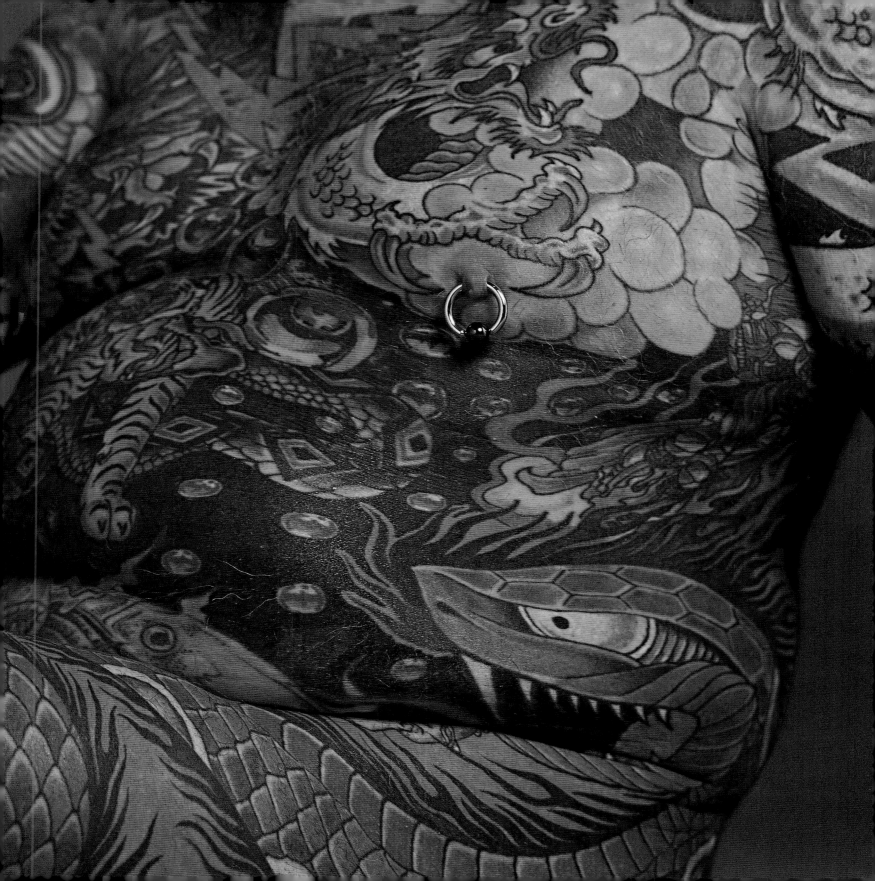

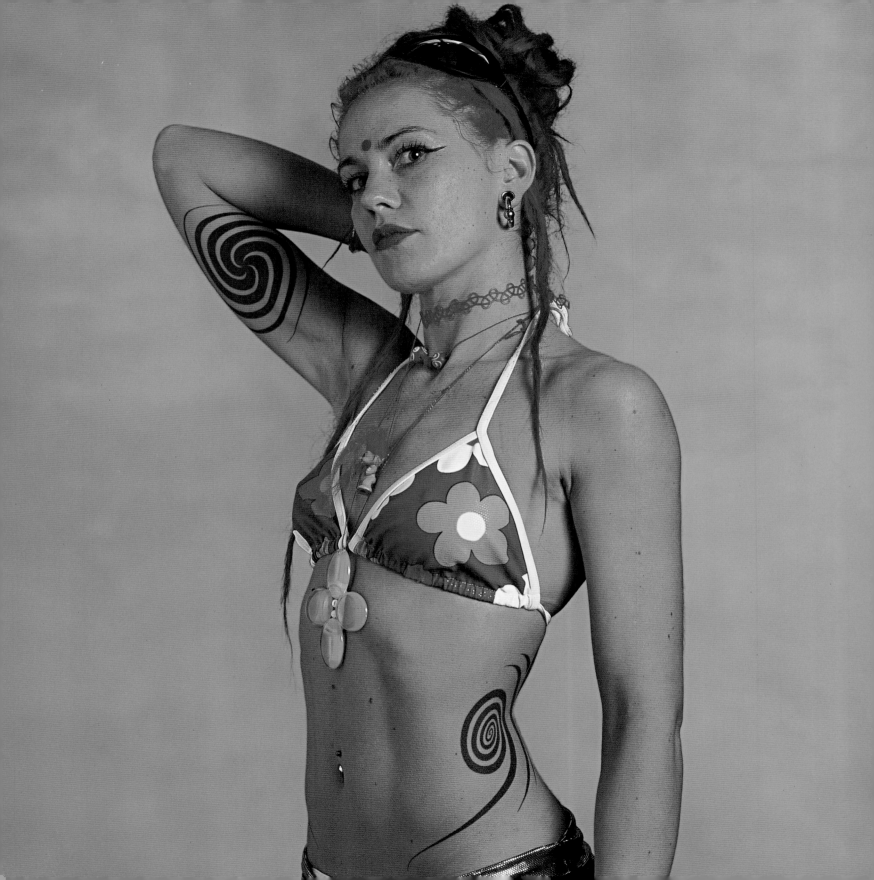

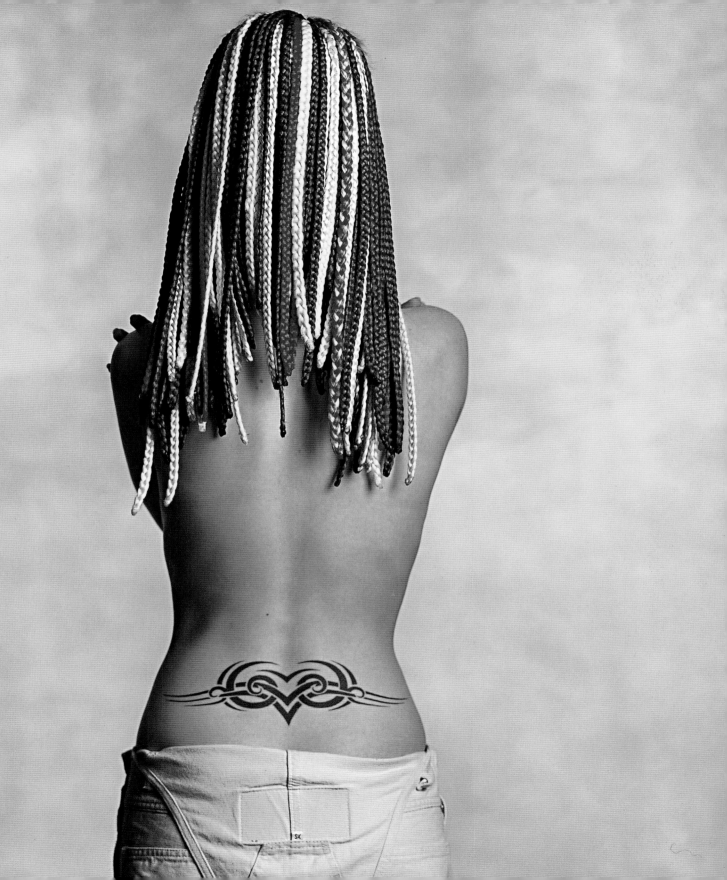

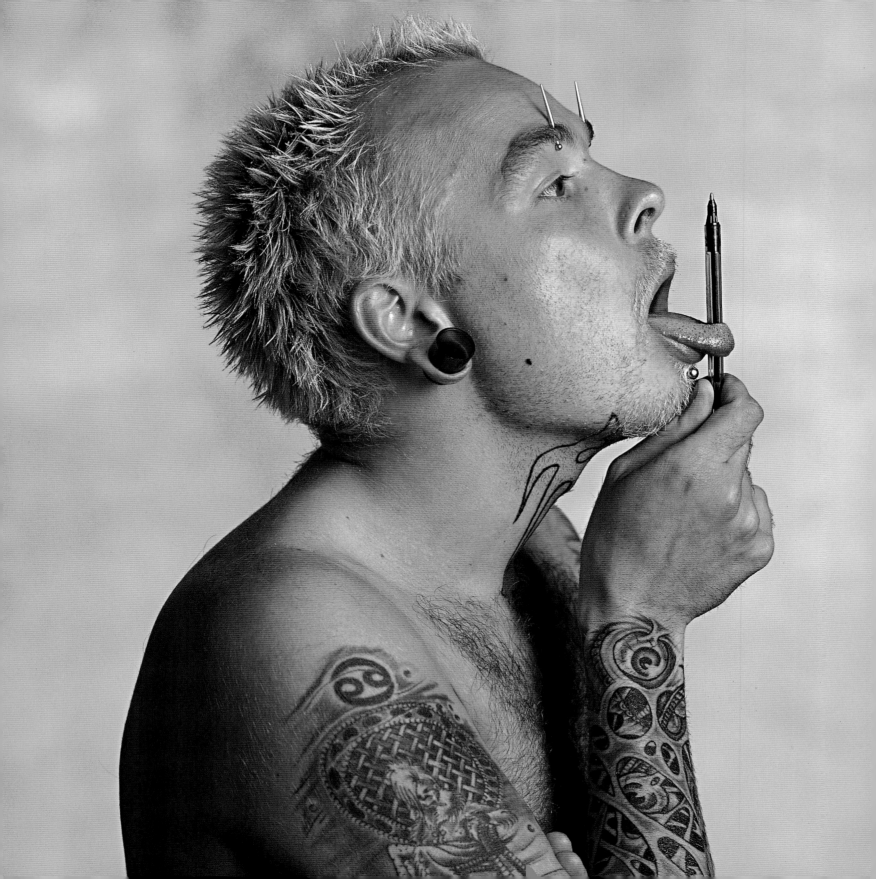

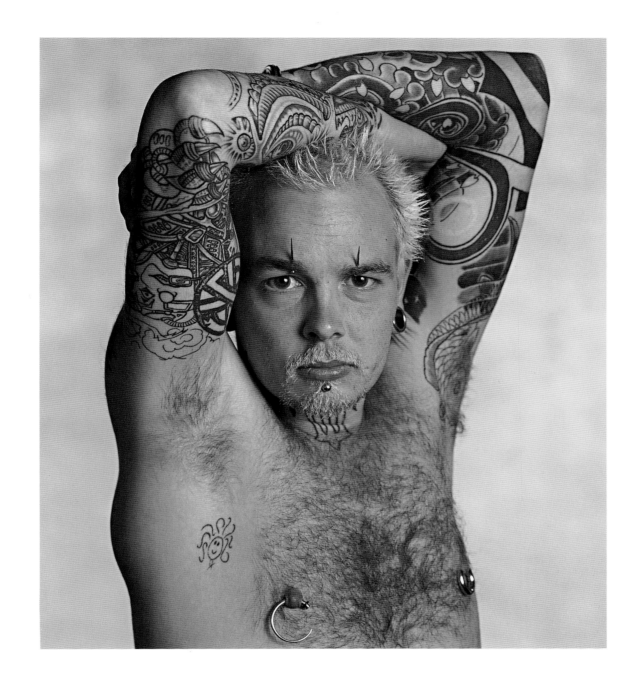

"People will always react, but hey, they've reacted to Hitler as well as Jesus, they react to fat people, ... they will react!"

Robert

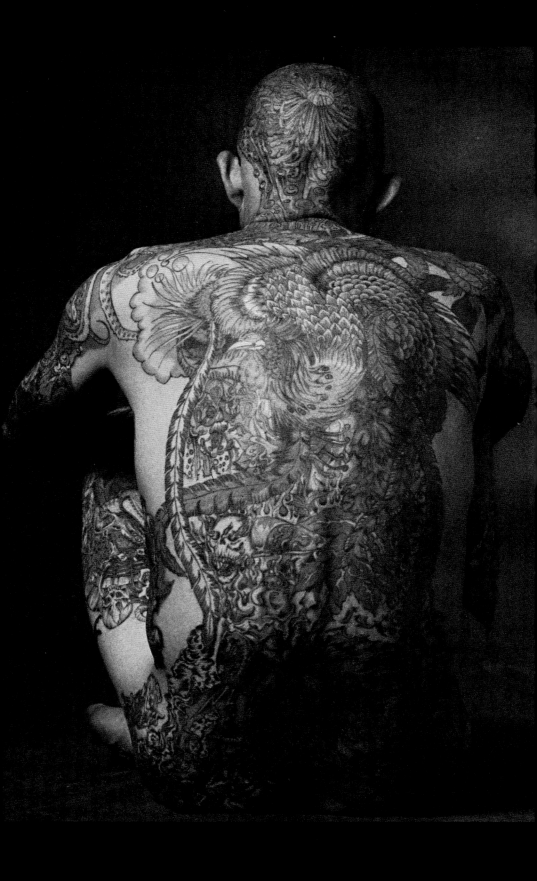

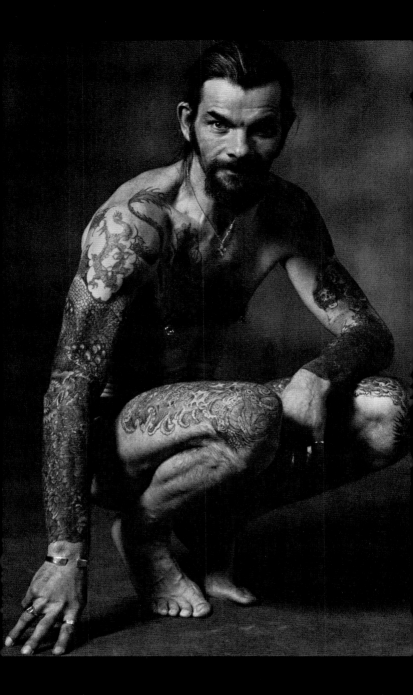

"Tattoos make you different from everyone else. Once you have one you can't stop."

Mick

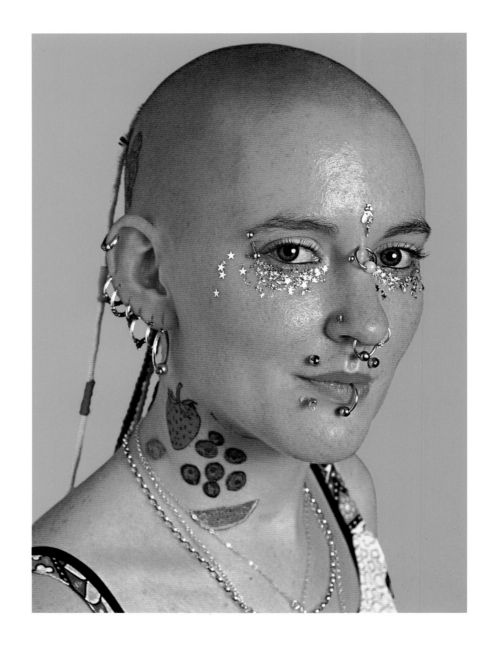

"I like my Jelly Babies because I think they are cool."

Moon

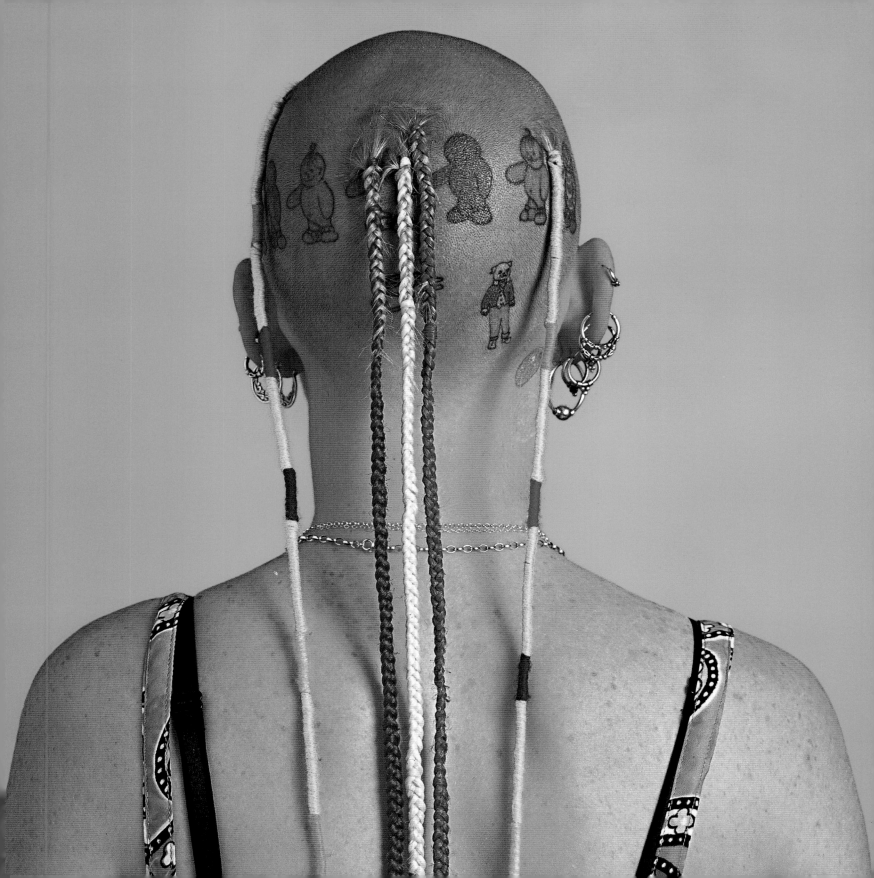

"It is accepted that 'Art' is hung in whitened, hushed galleries ... playing that grand old game, The Emperor's New Clothes. Tattooing breaks all these rules, living as it does with the owner's breathing carcass."

Joolz

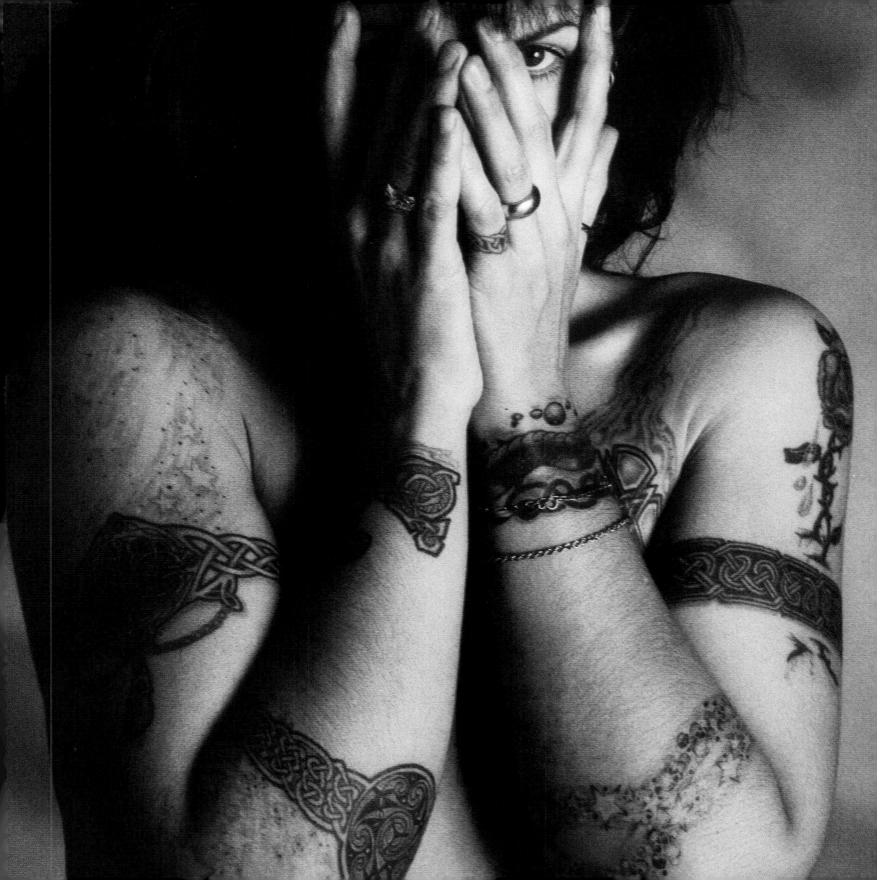

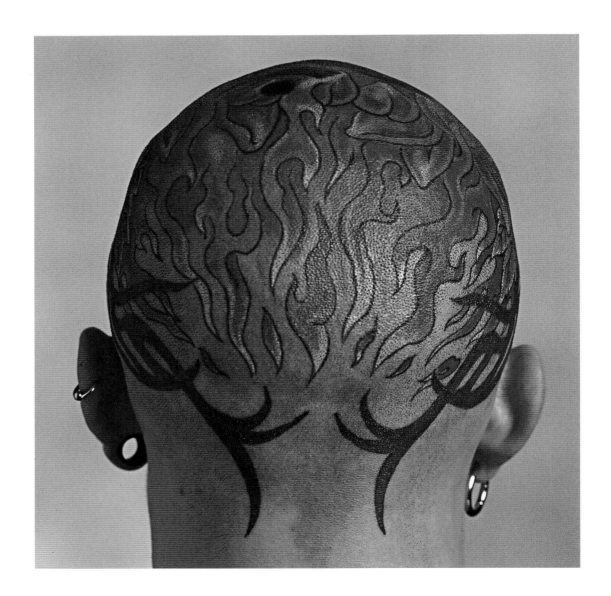

"All of my tattoos mean something to me. My head has been the most positive thing I have ever done, with very deep meaning for me. The lotus flower is symbolic of enlightenment and the energy point on the top of the head is known as the thousand-petalled lotus chakra."

Raja

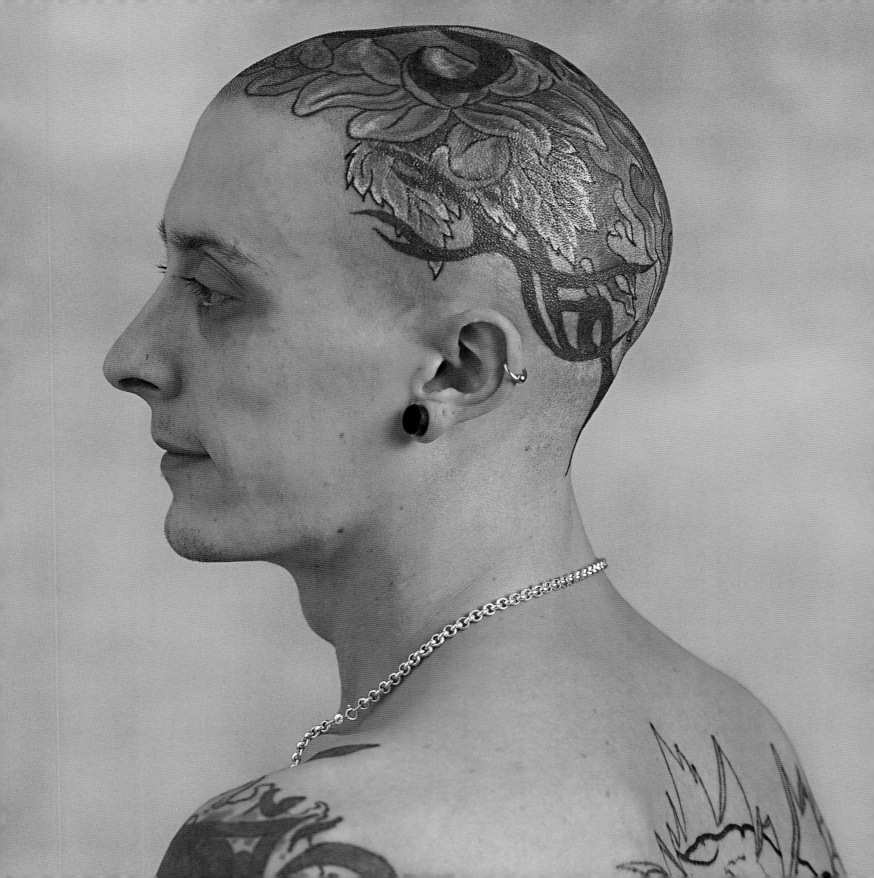

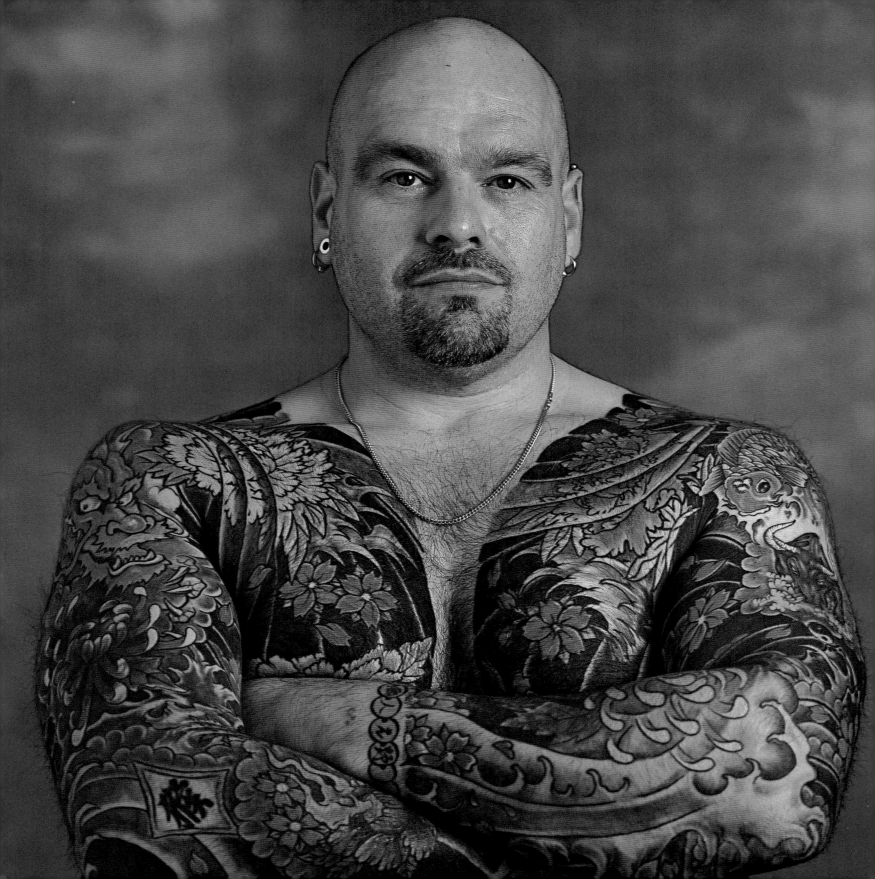

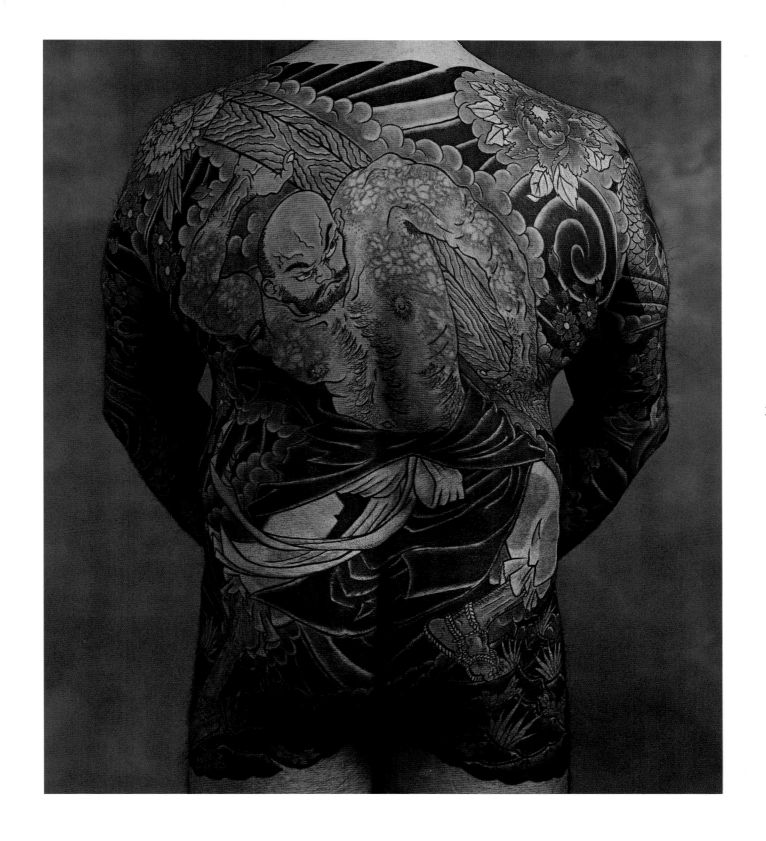

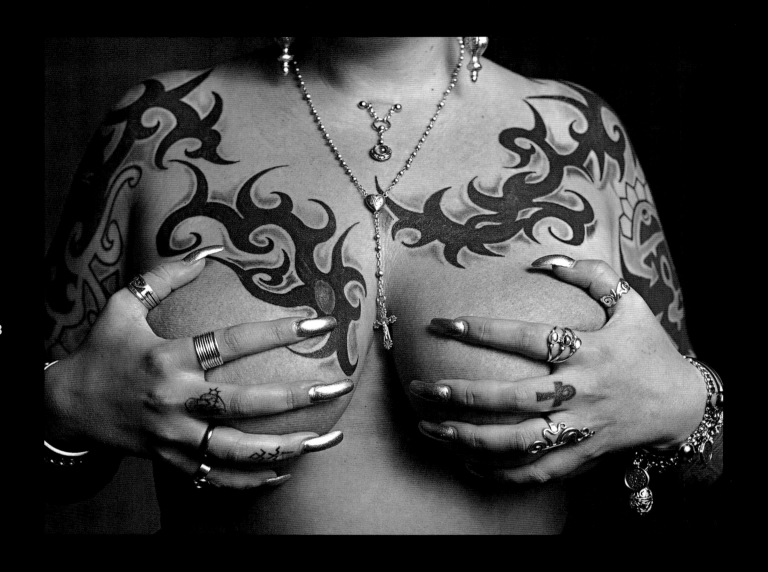

"Some people get scared or they want to feel if it's real."

Miranda

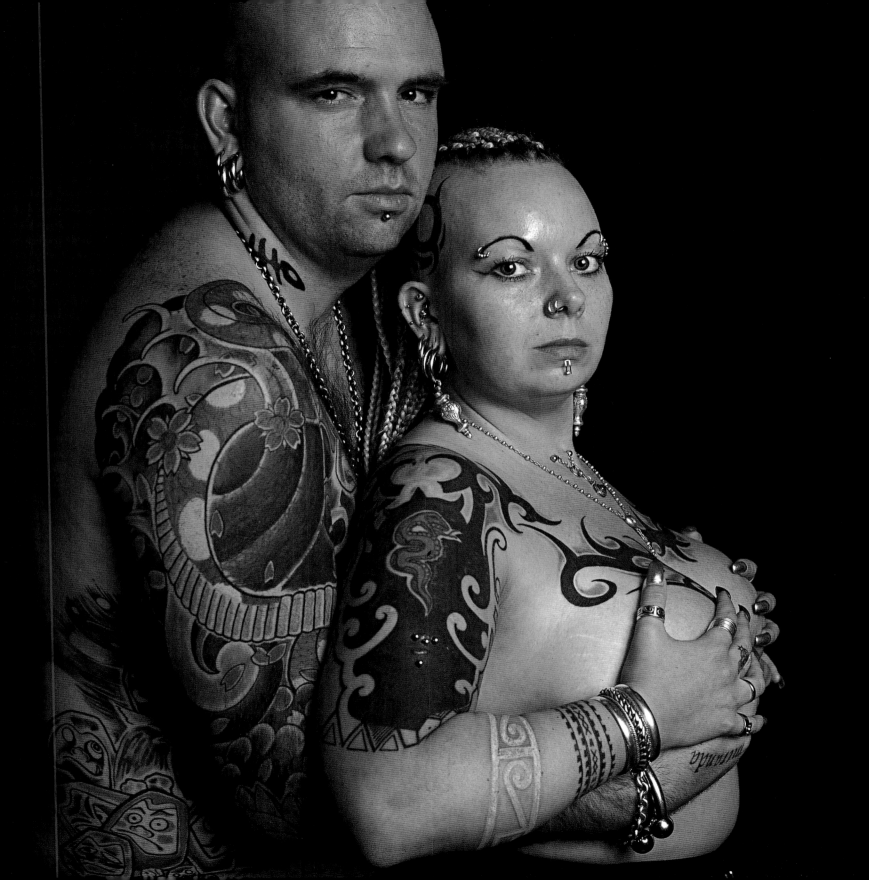

"My back is my favourite ... Rock 'n' roll means a lot to me."

Peggy

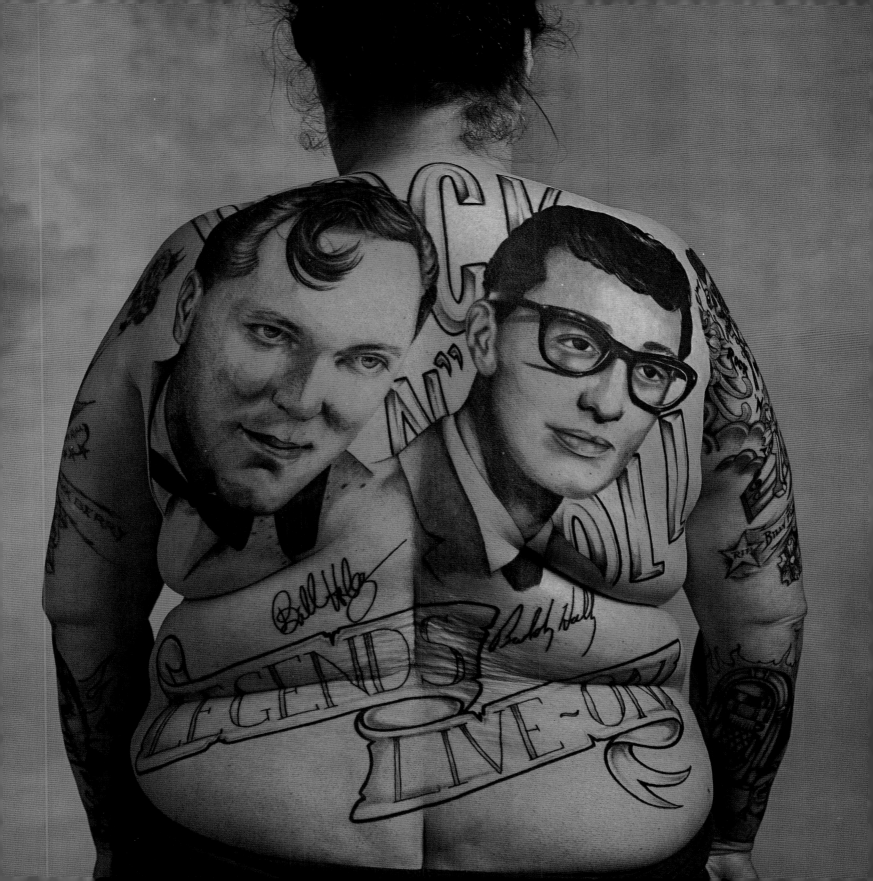

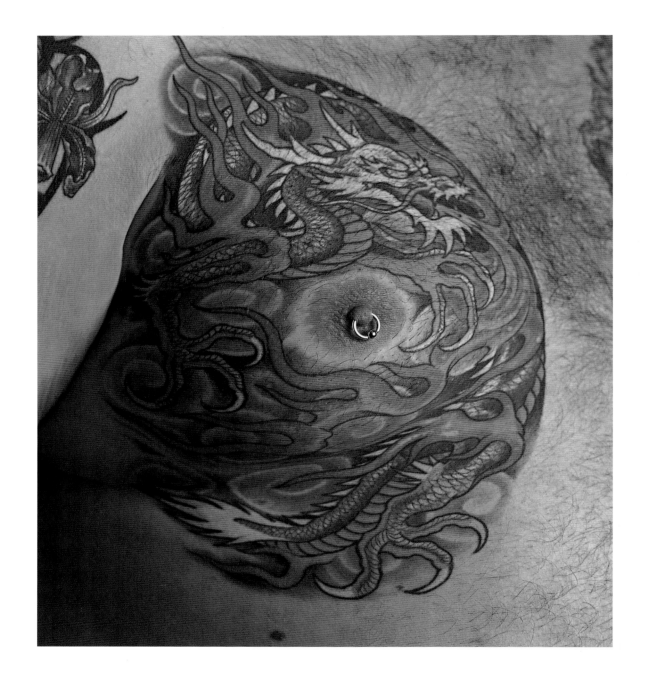

"People can be judgemental on first meeting, until they get to know me."

Gertie

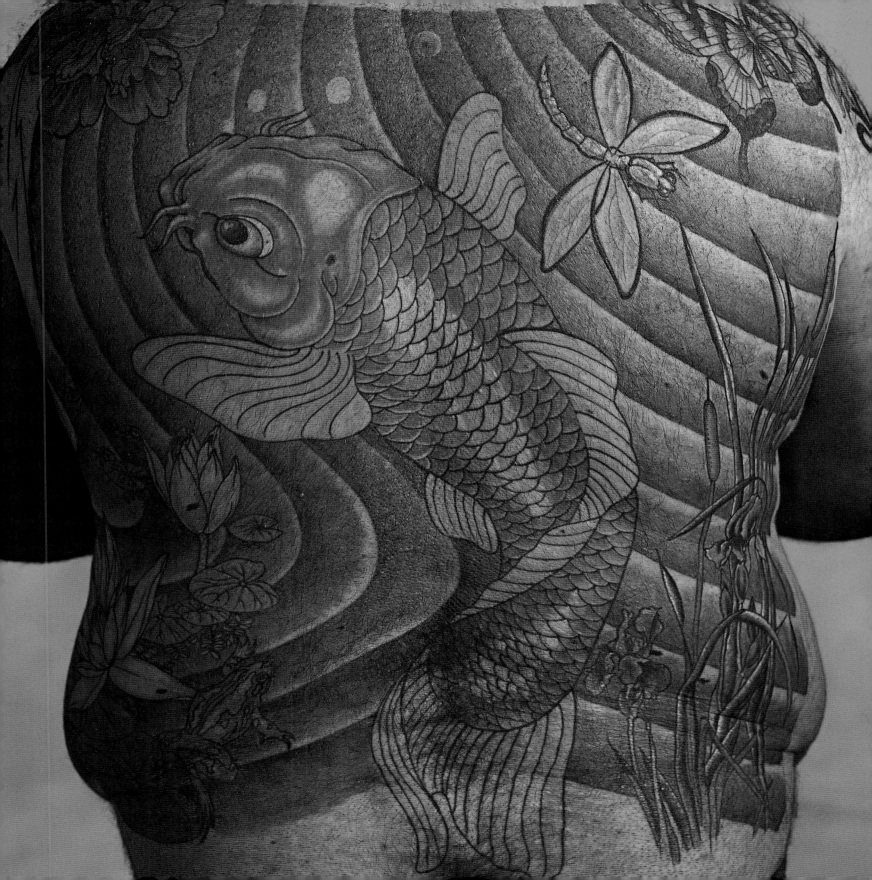

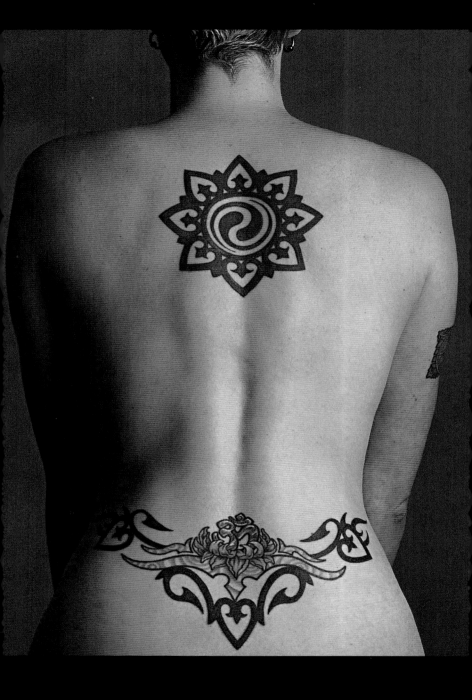

"I'm very proud of my back-tattoo ... I see myself in it, because it's a slave-girl and so am I."

Patricia ☞

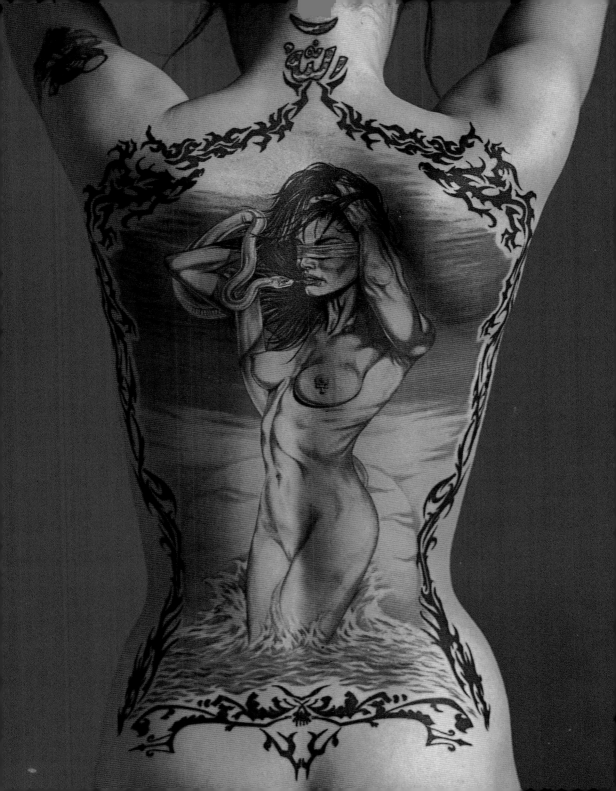

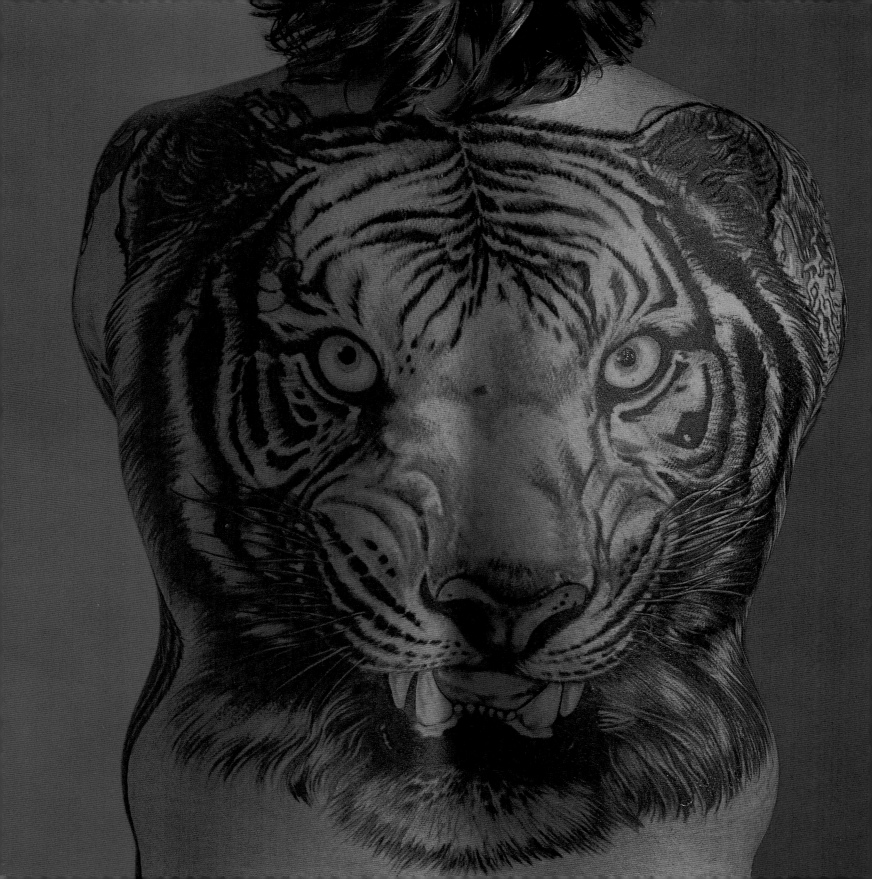

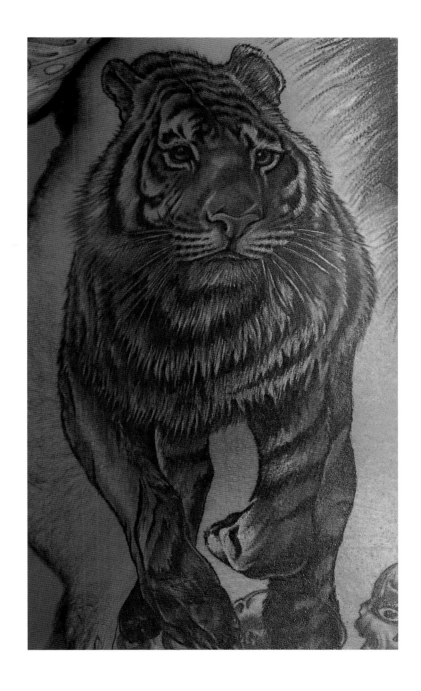

"I had the tigers done because they are such spiritual creatures."

Alun

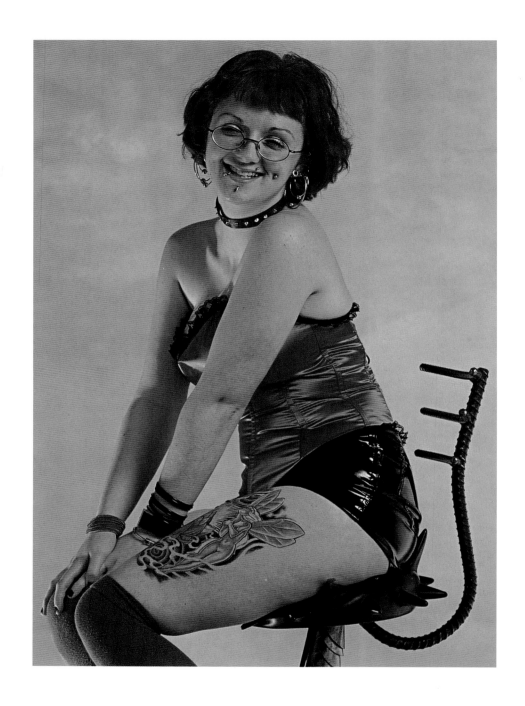

"It's my one and only ... for now."

Bekki

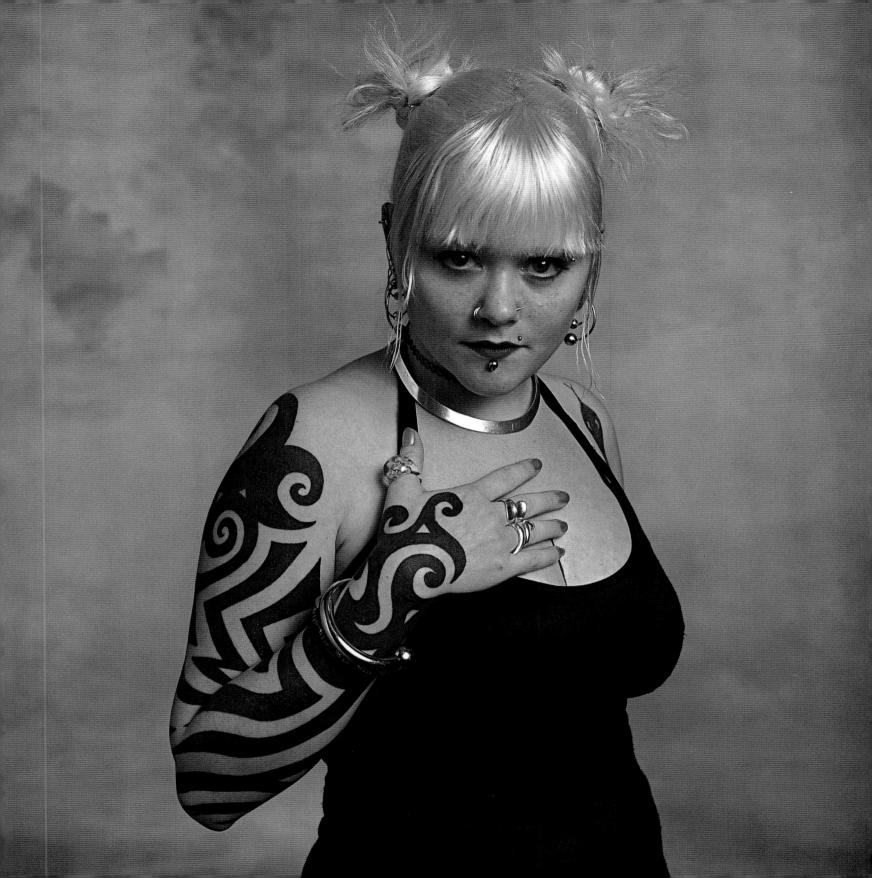

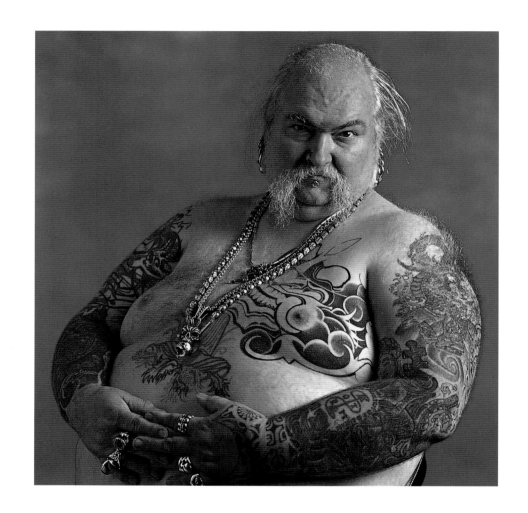

"My favourite tattoo is the face on my arm."

Mike

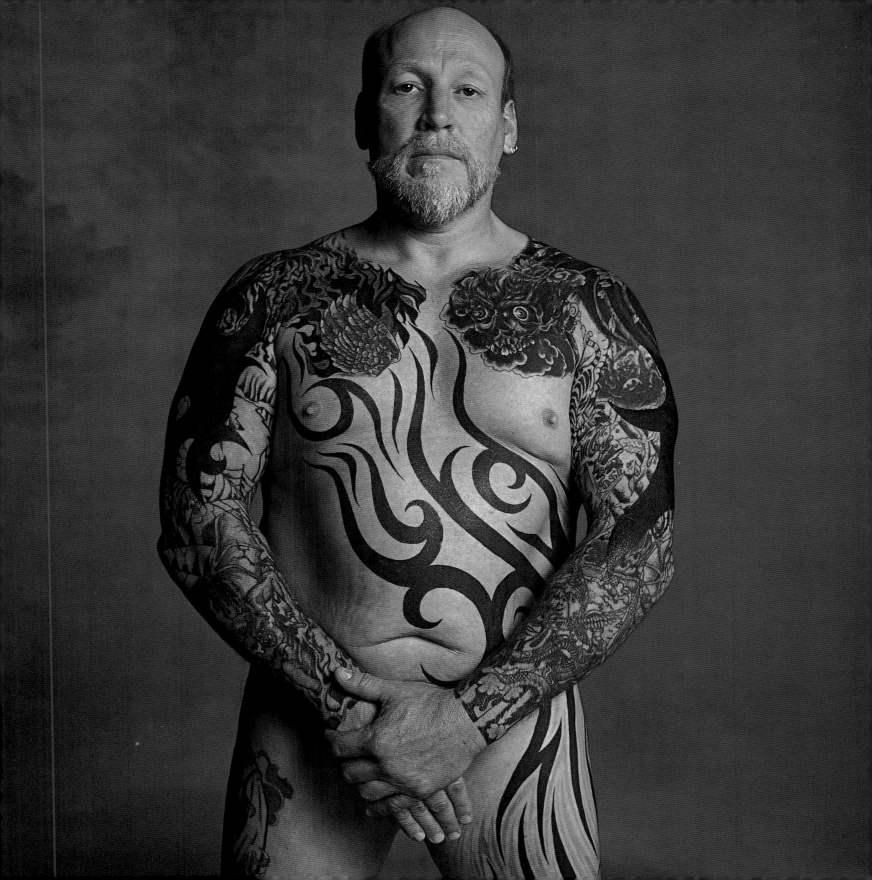

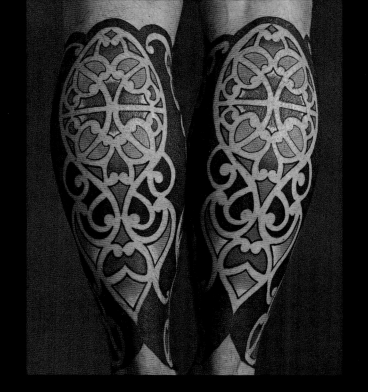

"I just like tattoos in general ... My first tattoo was a skull."

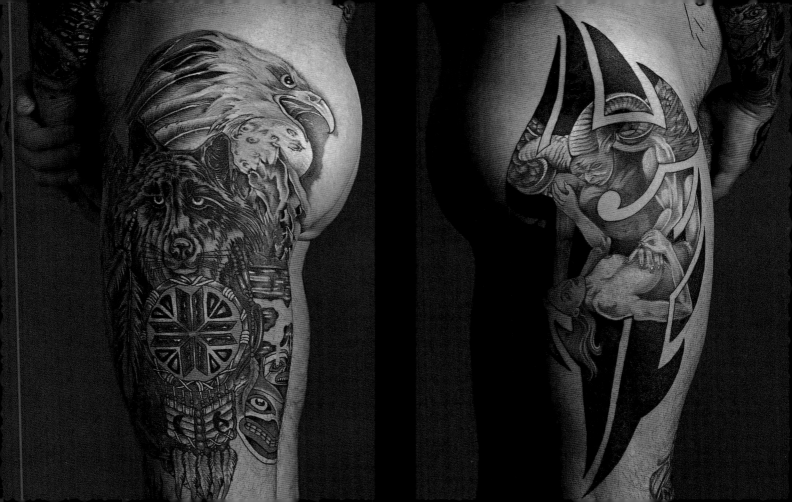

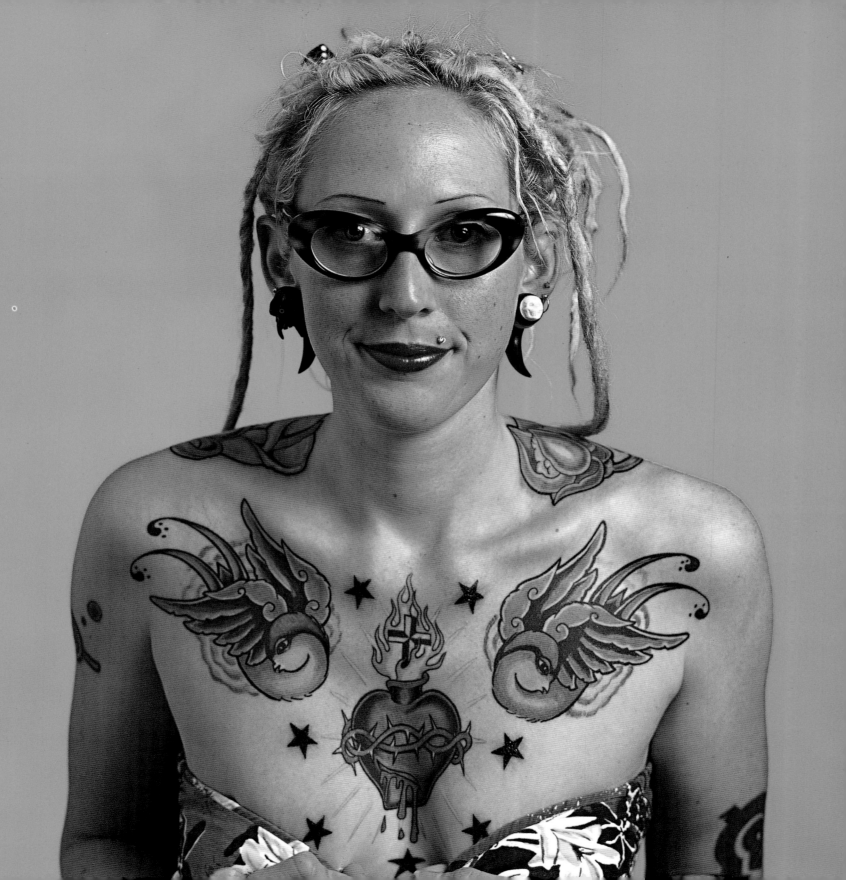

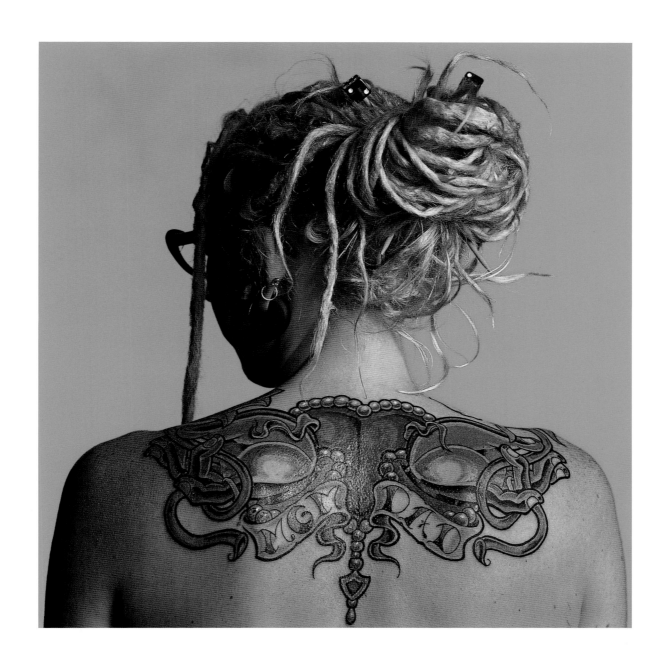

"I am completely in love with 50s Americana and want to be as white trash as I can possibly be."

Zoe

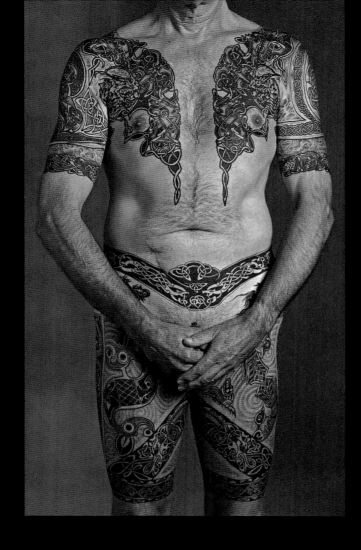
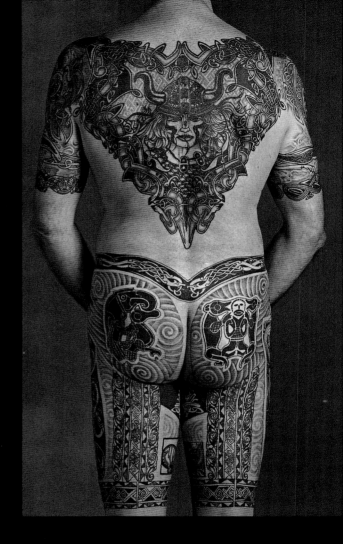

"It feels good to be tattooed."

Marius

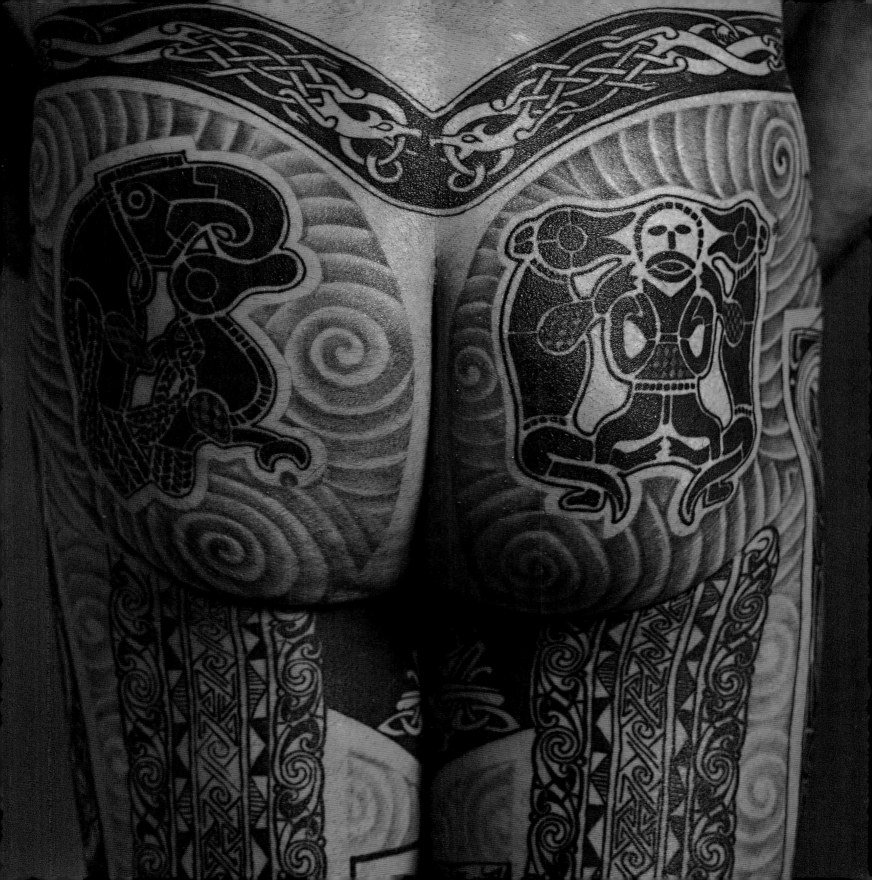

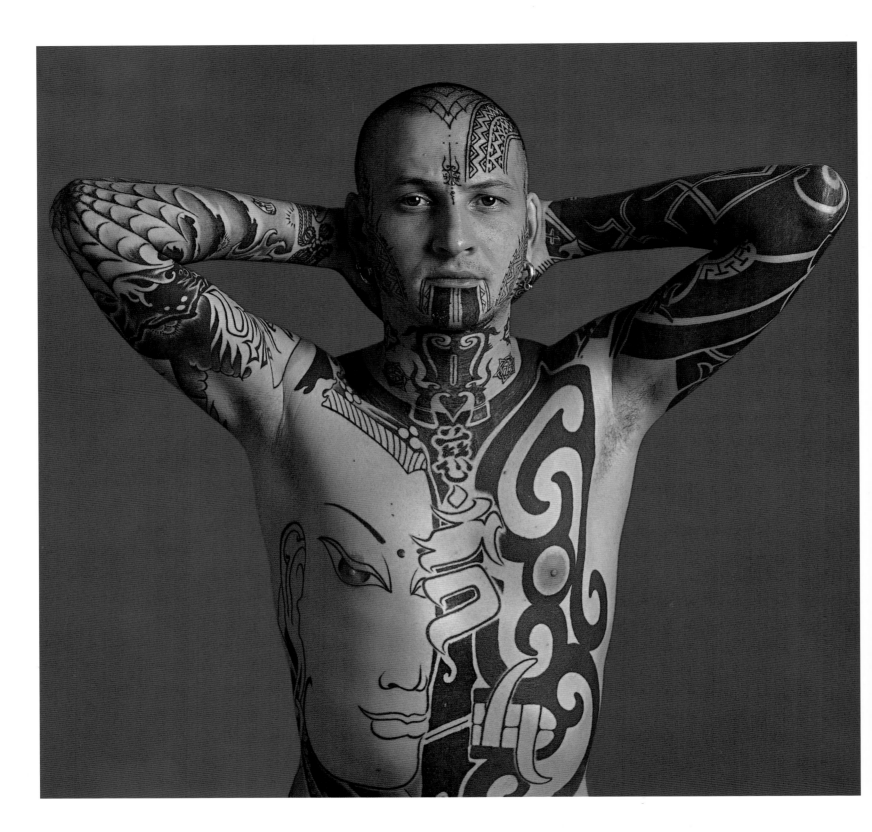

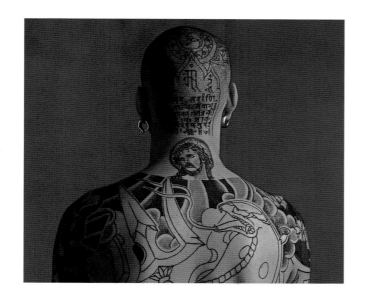 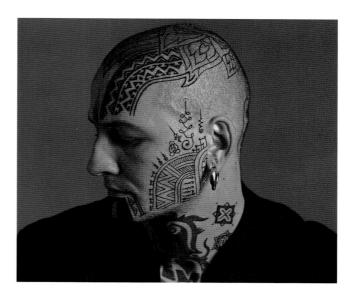

"I'll go all the way ... I don't care. My favourites are my face and head ... the head is the centre of the human body ... all my tattoos are religious."

4 9

Tas

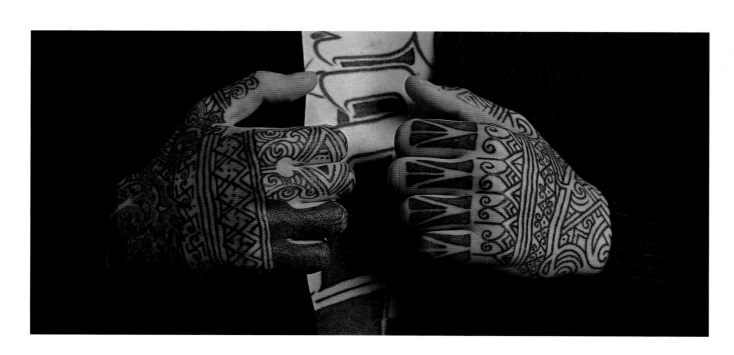

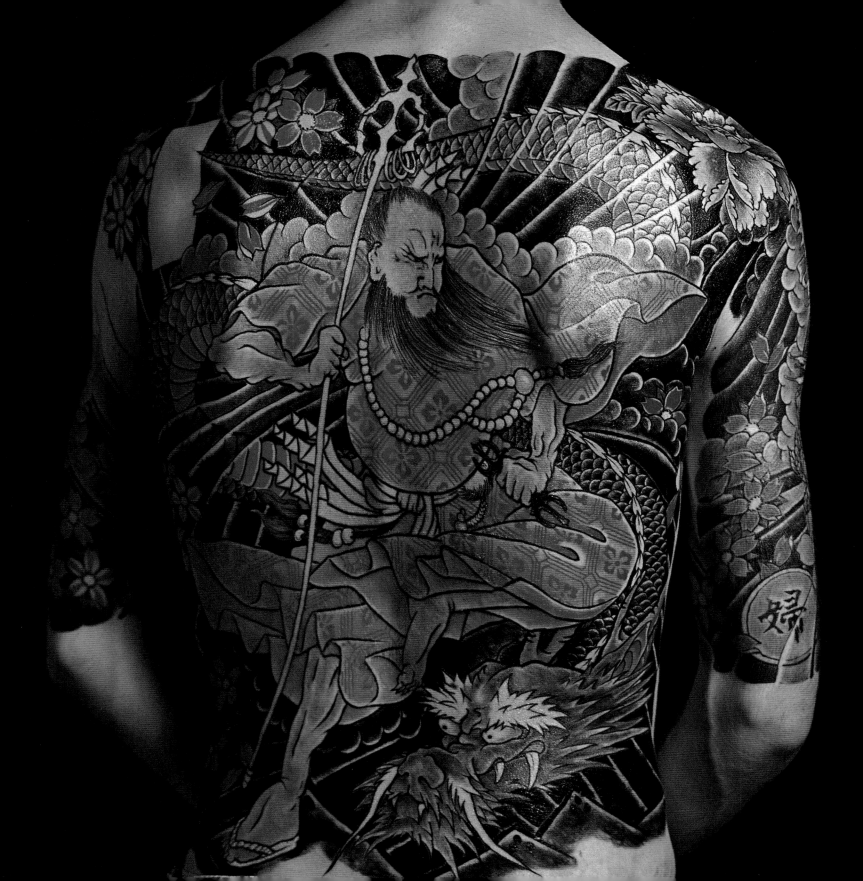

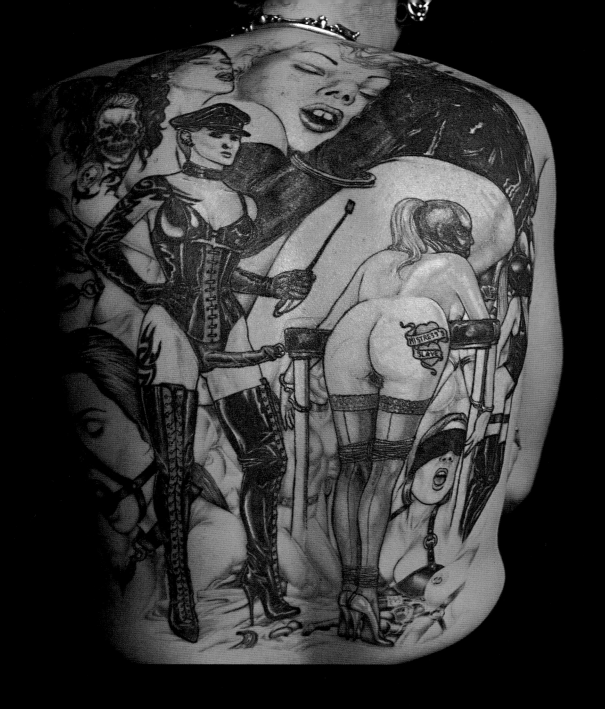

"I like pictures of women in bondage ...
Yes, it hurts. Yes, they do think I am a freak."

Nick

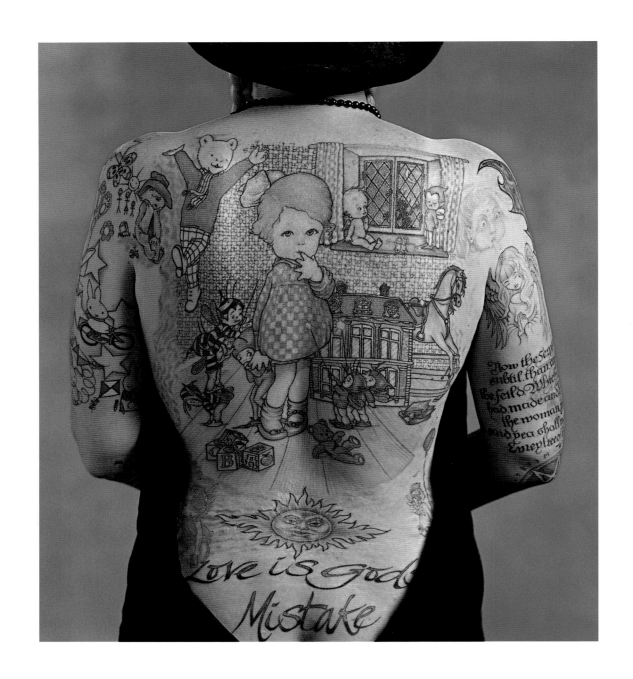

"The back piece is my favourite.
I had it as it is a reminder of how I used to be."

Michele

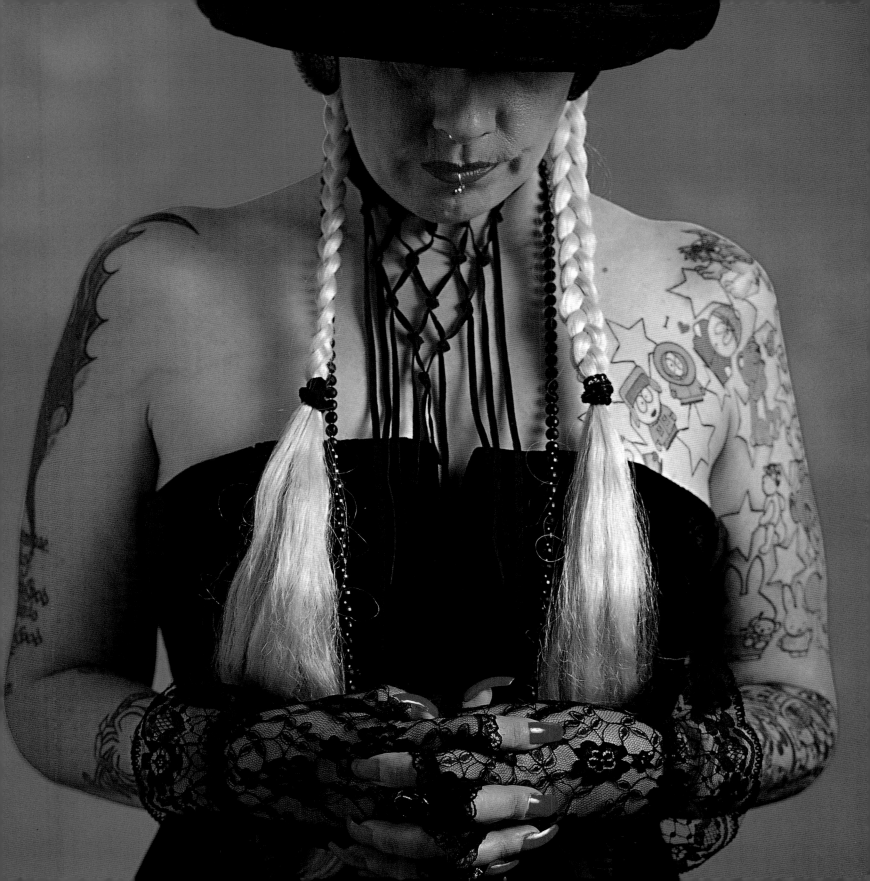

"I love honeysuckle because of its strong scent,
and lilac because of the beautiful butterflies it attracts."

Anna

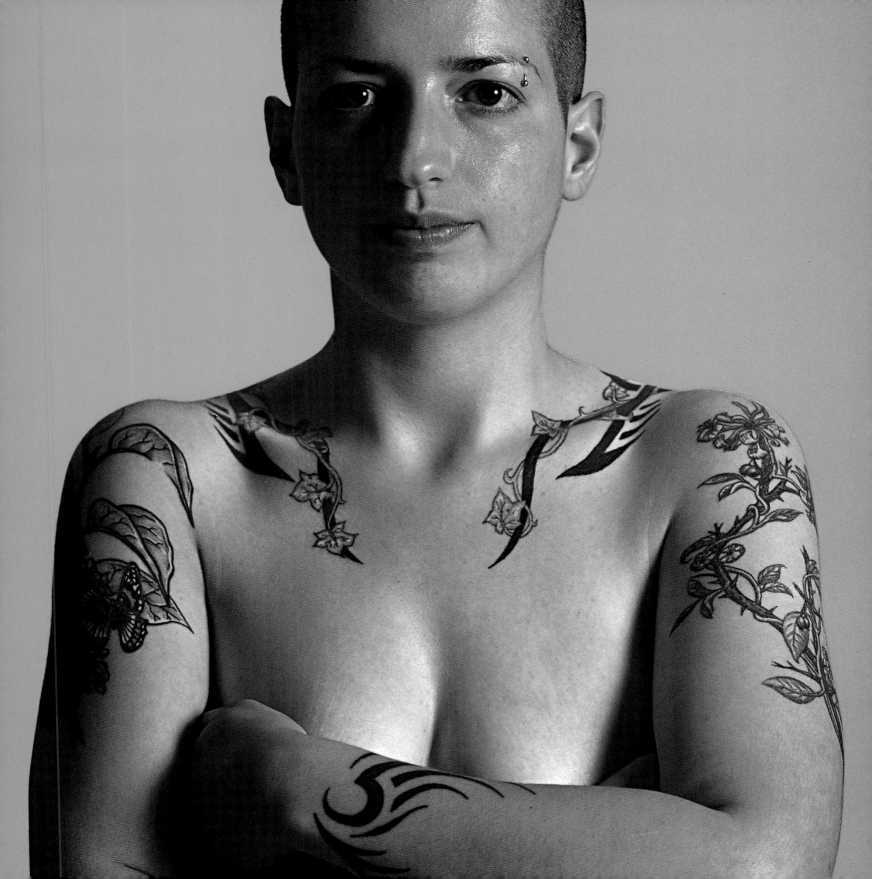

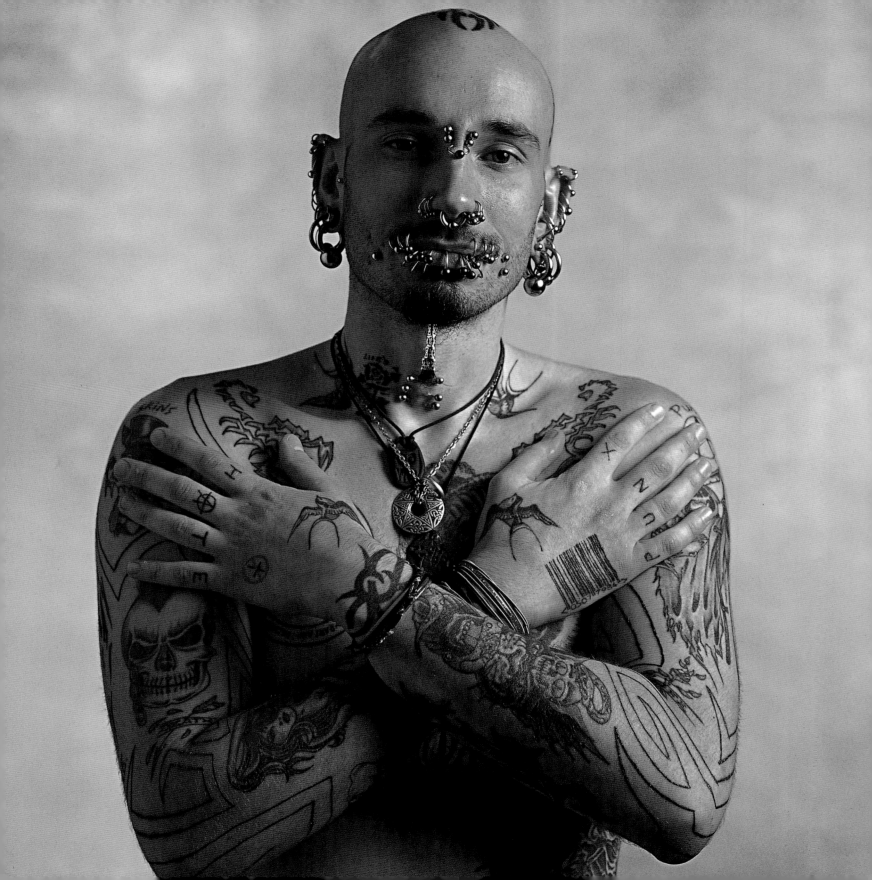

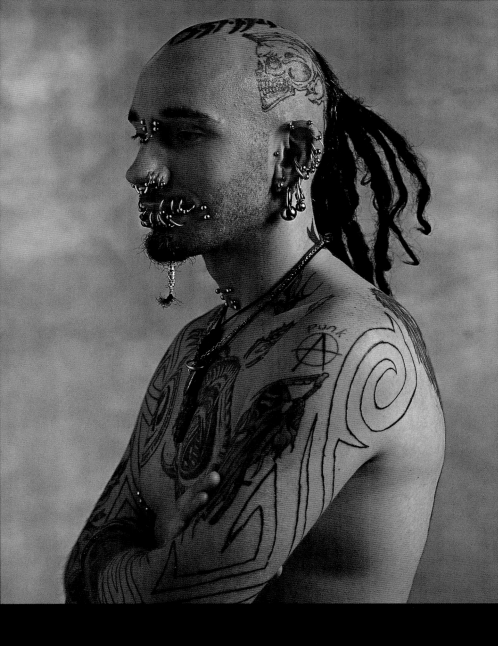

"My tattoos are part of me and stand for everything I believe in."

Spud

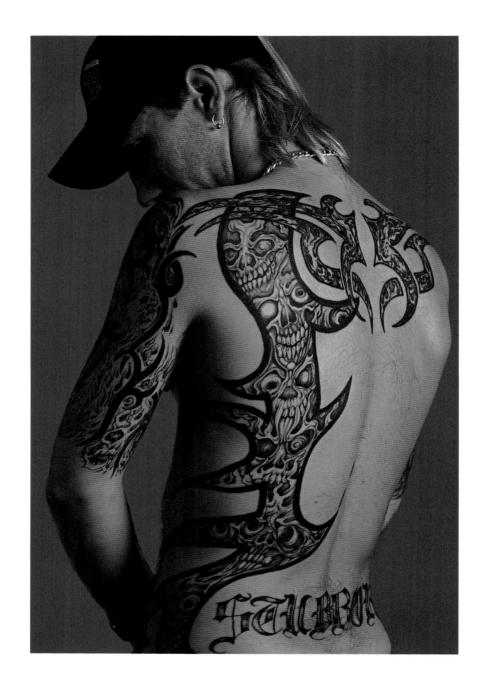

"I'm not religious, I just like Jesus and crucifixes."

Jacky ☞

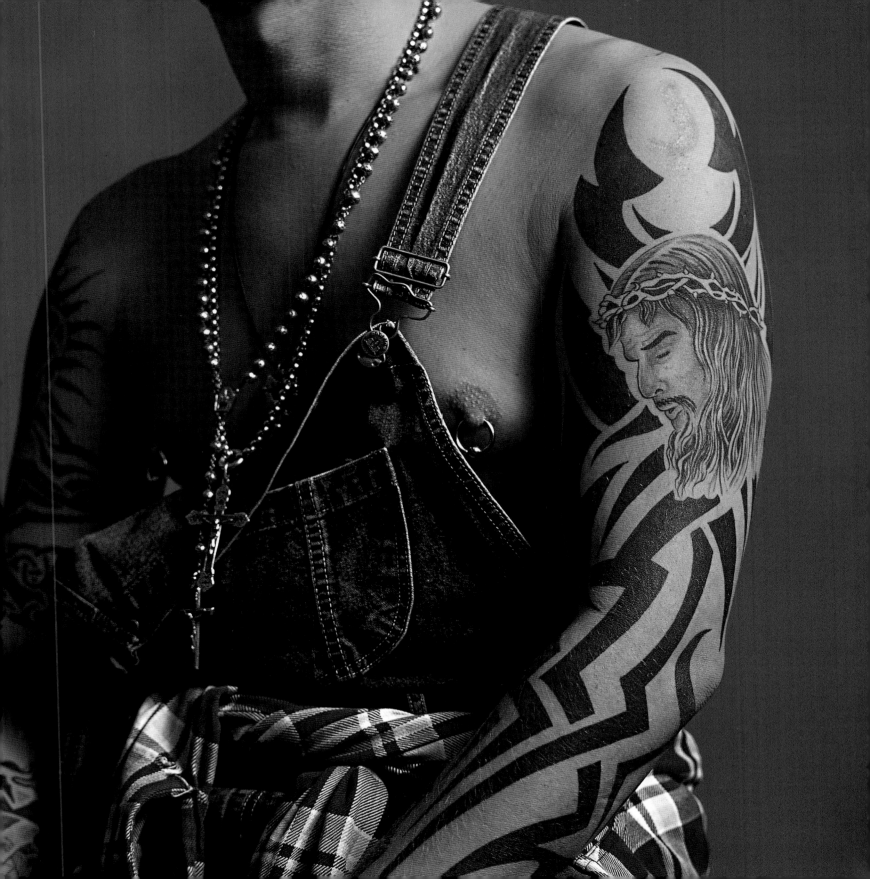

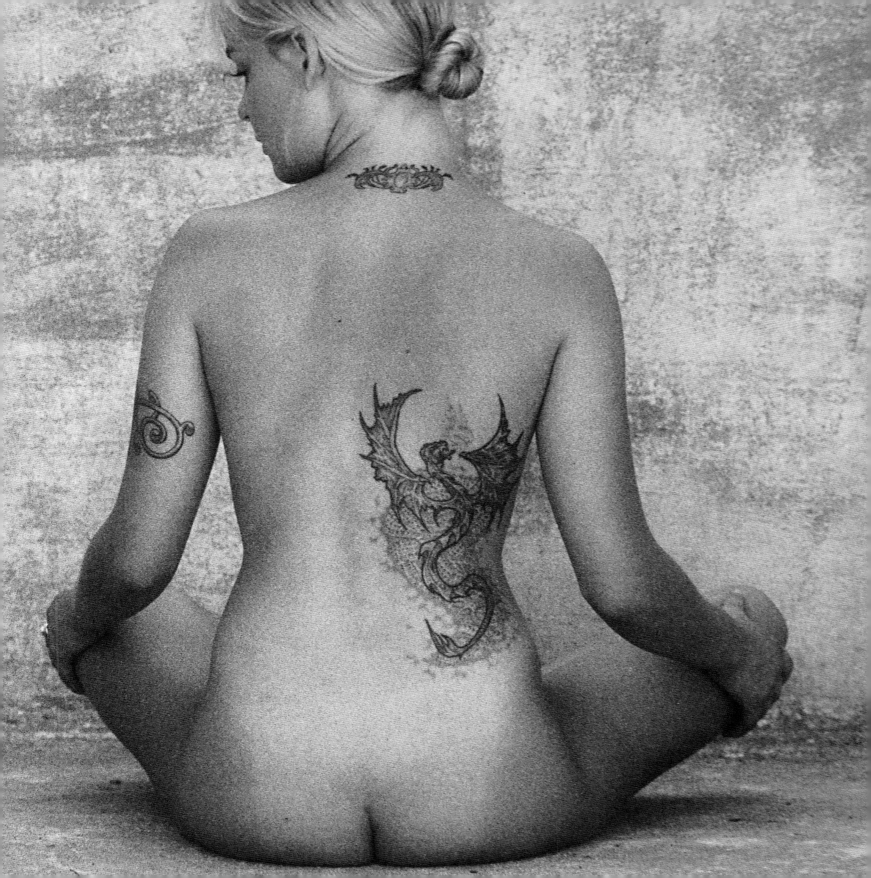

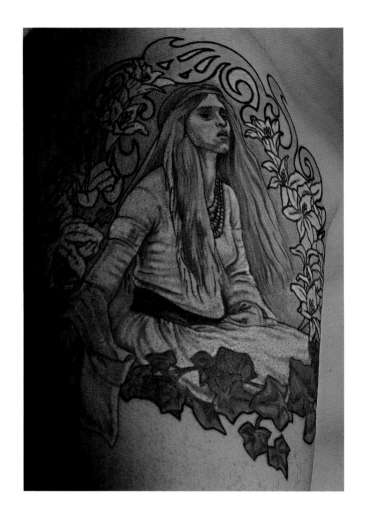 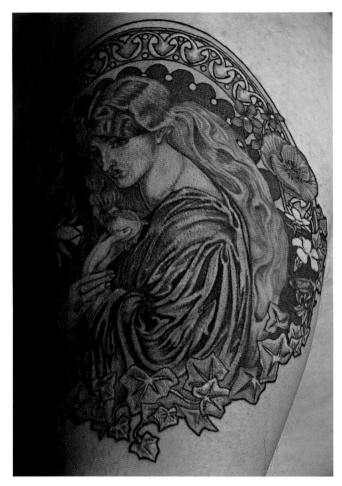

"The Lady of Shallot by J.W. Waterhouse and Proserpine by Dante Gabriel Rossetti — essentially they represent death and rebirth."

Terry

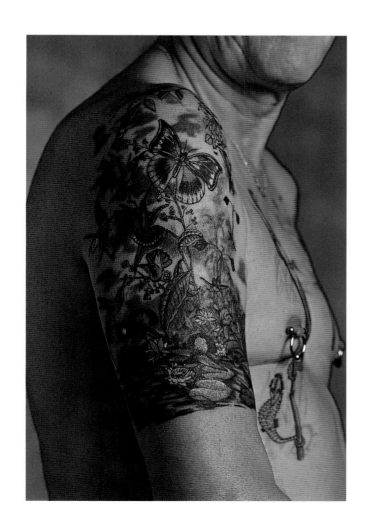

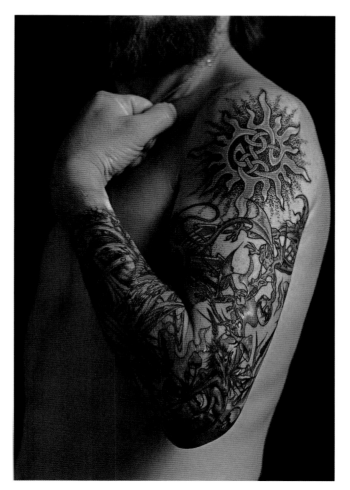

"All my tattoos are drawn from Nature.
The butterflies are my favourite."

Michael

"Once you've had one, you have to have
more — it's addictive."

Simon

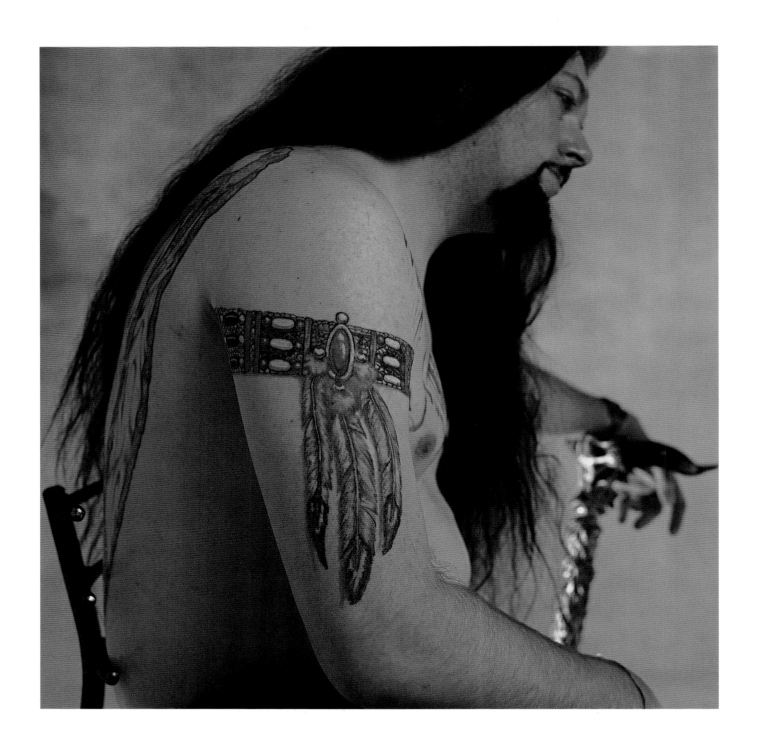

64

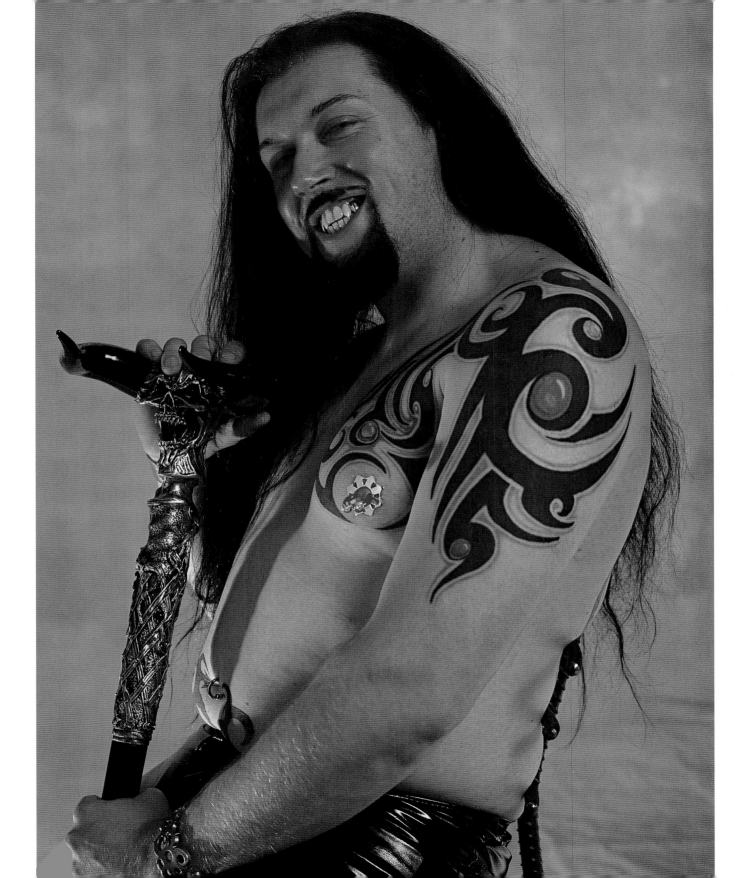

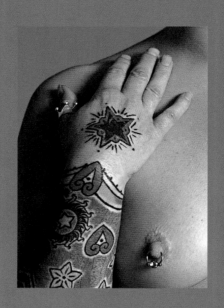

"I had my first tattoo when I was fourteen years old,
but don't tell my Mum!"

Marlboro Mary

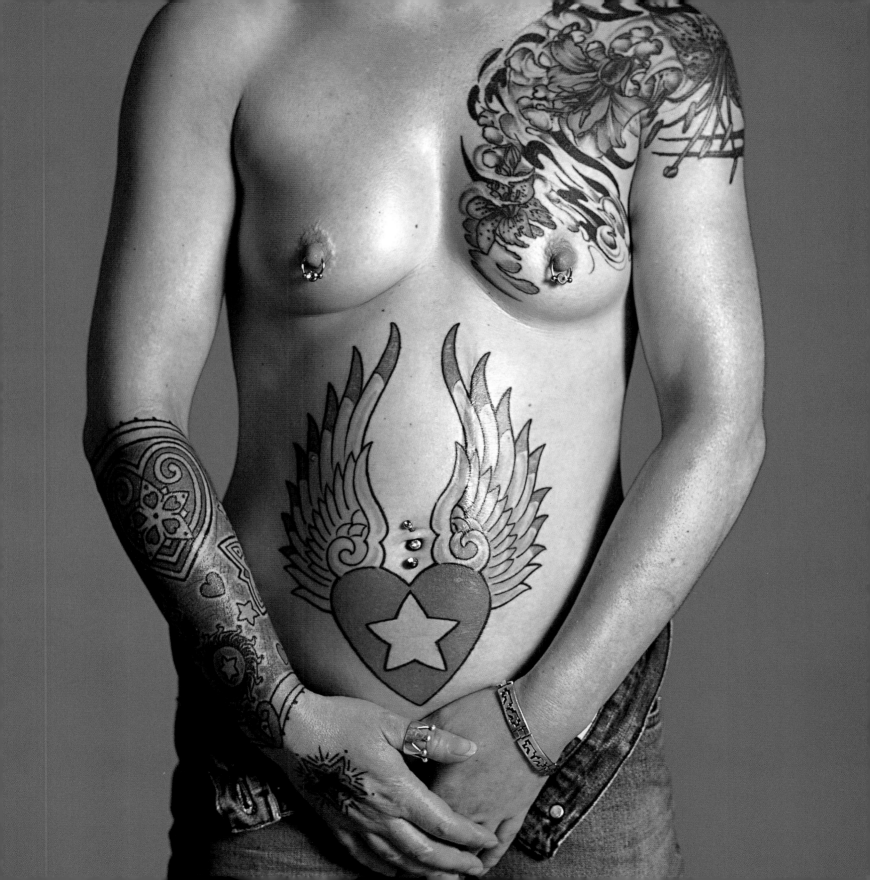

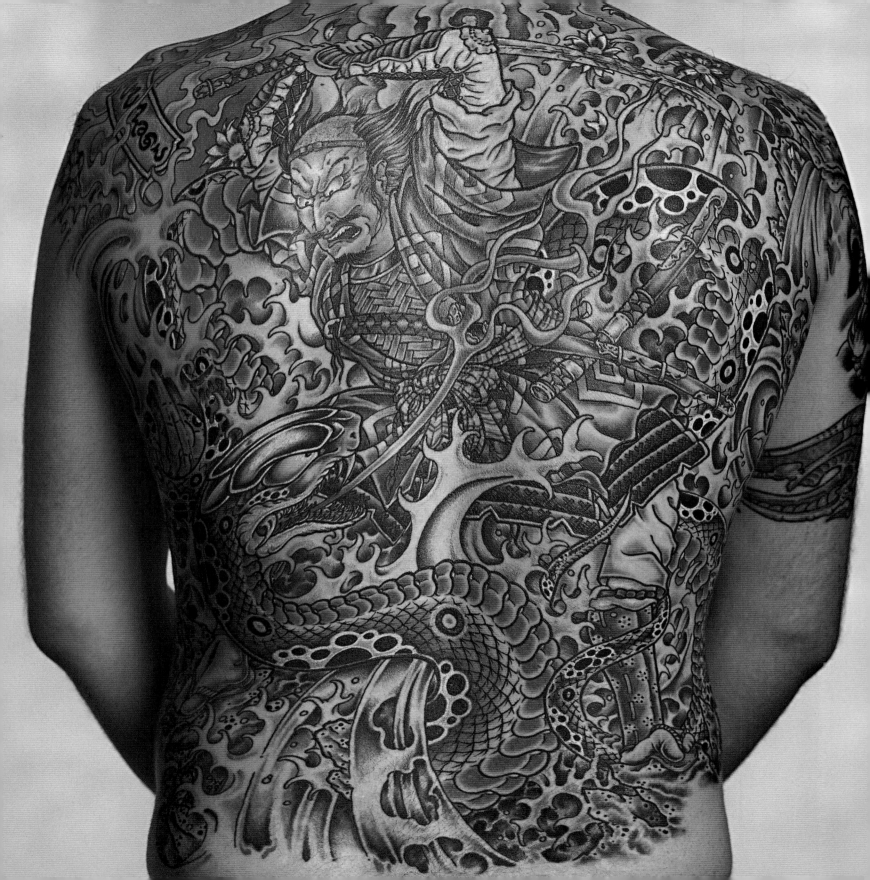

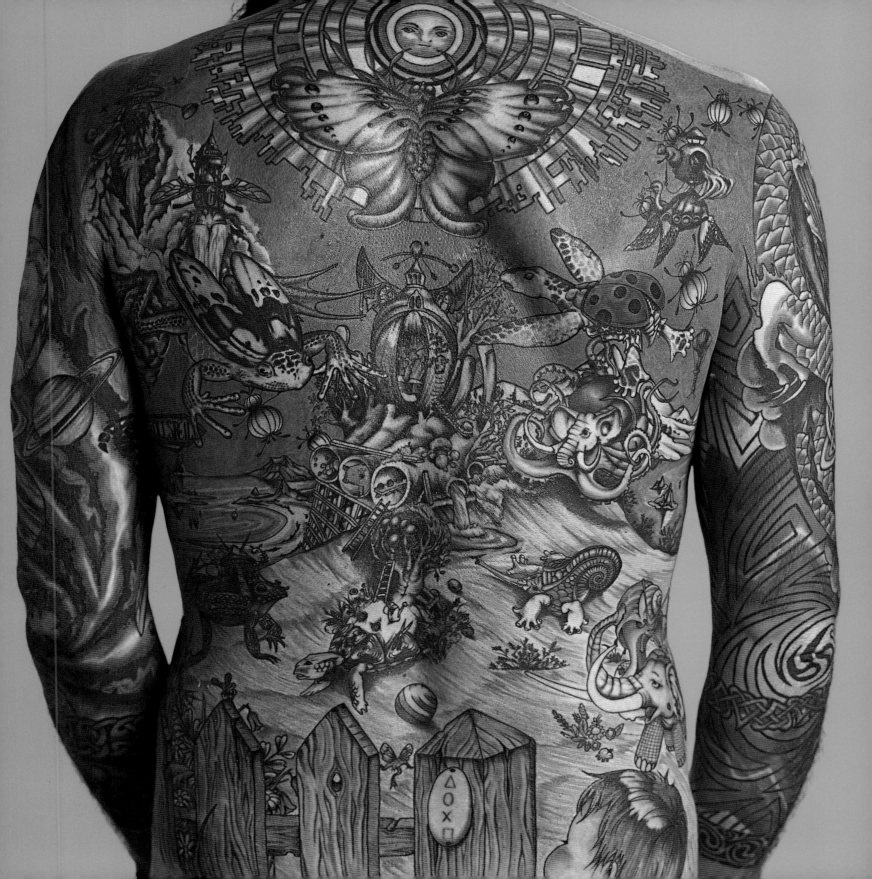

"I am a collection of tattoo artists' work."

Steven

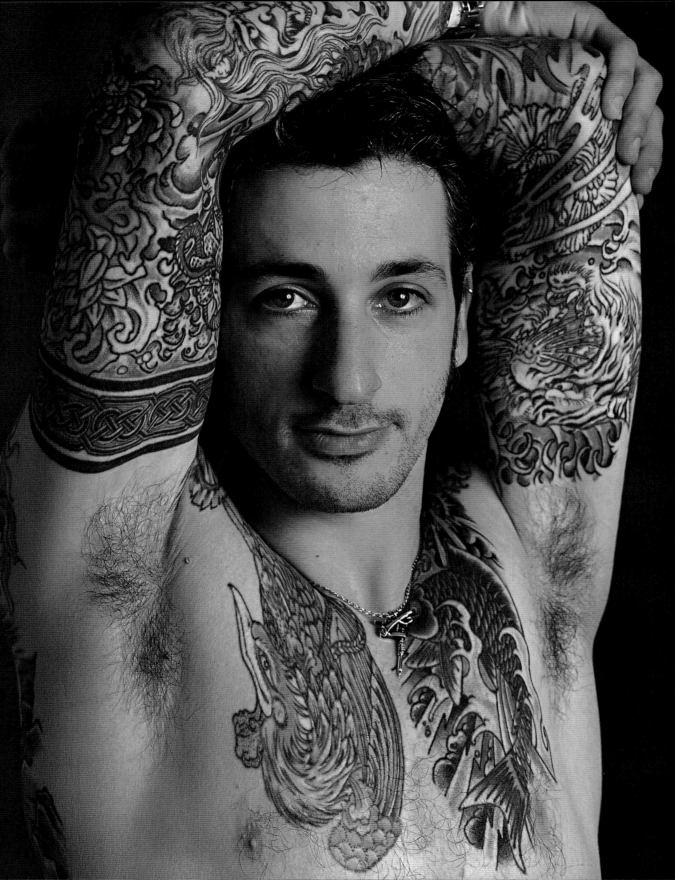

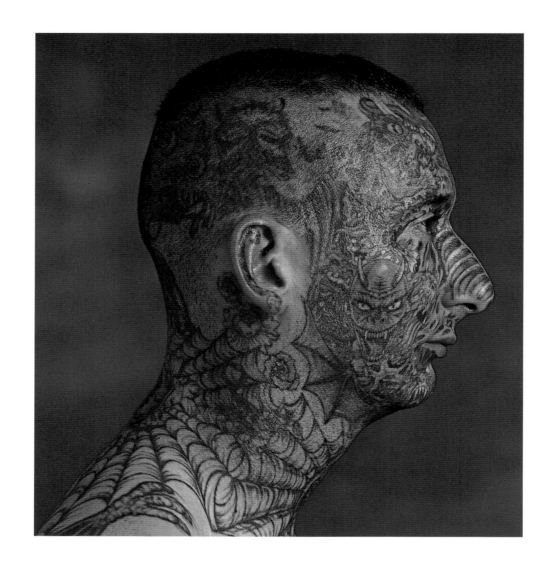

"The spider's web on the neck is the best at the moment."

Mark

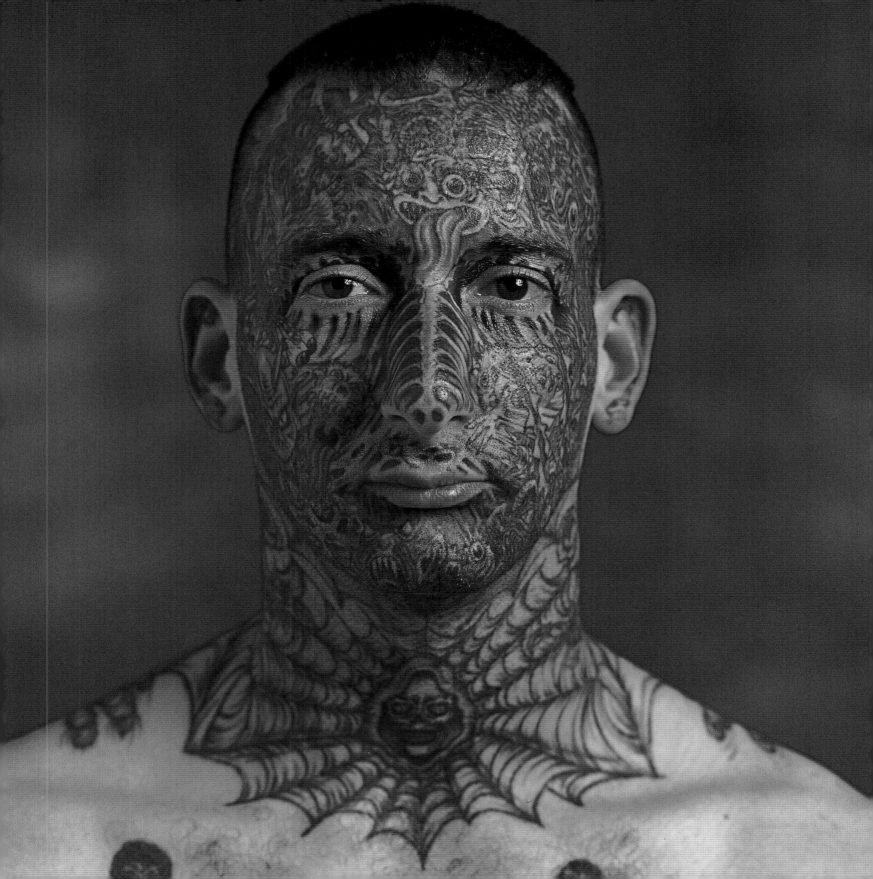

THE MODELS

"This short life is all we have, so we may as well do with our bodies what pleases us."

Joolz, poet

pages 2, 48–49
Tas
Age 28
Tattooist

Artists: Mike @ Mike's Family, Athens
Yorg @ Mike's Family, Athens
Curly @ Into You, London
Alex Binnie @ Into You, London
Paris @ Paris & Co, Nicosia
Steve @ Into You, London
and myself

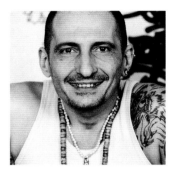

pages 5, 9
Claudio
Tattooist

Artists: Mike @ Mike's Family, Athens
Yorg @ Mike's Family, Athens

"It's not just for the money ... if you do anything on the skin it will last forever, so the work has to be right."

pages 10–13
Larry
Age 70
Programmer, analyst
Artists: Carlo Peck @ Clean &
Sober, El Paso
Ed Harvey @ Realistic, San Francisco
Cliff Raven @ cliff Raven, San
Francisco and Los Angeles
Bob Roberts @ Starlight Tattoo, LA
Eddie Deutsch @ Tattoo City,
San Francisco

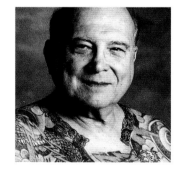

page 14
Eva
Age 27

Artist: Pink @ Tattoo Pink, Hasselt

"The first tattoo was the eagle on my shoulder ... I want to have many more tattoos. I think [that] people react very positively [to them]."

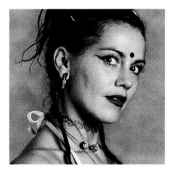

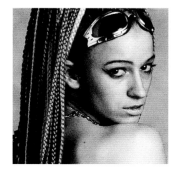

page 15
Sam
Age 26
Waitress

Artist: Pink @ Tattoo Pink, Hasselt

"The one below my back is the only one I've got. It doesn't mean anything to me, I just think it's beautiful!"

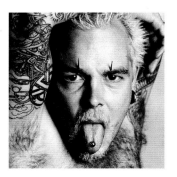

pages 16–17
Robert
Age 25
Hairdresser

Artists: Mick @ Tattoo Mick,
Dortrecht
Daan @ Daruma, Antwerp
Robert @ Tattoowest, Rotterdam
Hans @ Tattoo Mick, Dortrecht
Rinto @ Tattoo Rinto, Groningen

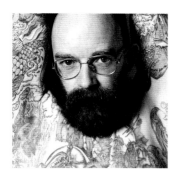

page 18
Bob
Age 53
Driver

Artist: Mick Narborough @ Skin
Graphics Tattoo Art, London

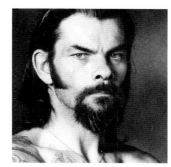

page 19
Mick
Age 53
Tattooist

Artists: Andy Barber, New
Malden, Surrey
Harry Potter, Essex
Darren Stars, Portsmouth
Jan Frost, Croydon, Surrey
Les Burchette, London
Tommy Downs, Lower Hut

pages 20–21
Moon
Age 21
Carer

Artists: Phillips, Northampton
Cliff @ Raw Hide, St Albans

"I love all my tats."

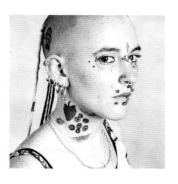

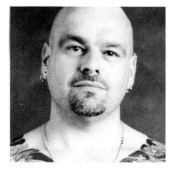

pages 22–23
Joolz
Poet and writer

Artist: Mickey Sharpz

7 5

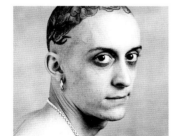

pages 24–25
Raja
Age 25
Works in tattoo supplies

Artists: Mark Fairburn @ Danny's
Tattoo Studio, Nottingham
Paul Lawn @ Danny's Tattoo
Studio, Nottingham
Paul Panlowski @ Danny's Tattoo
Studio, Nottingham

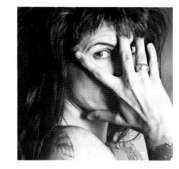

pages 26–27
Phil
Age 43
Tattoo Artist

Artist: Lee Symonds, Clacton-on-Sea

page 28
Miranda
Age 31
Body piercer and brander

Artists: Daruma Tattoo, Antwerp
Jacky @ Tattoo Studio, Nymegen

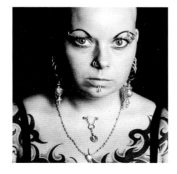

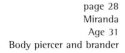

page 29
Peet
Age and profession unknown

Artists: Daruma Tattoo, Antwerp
Marco Bratt @ Katwijk, Katwijk
Michel @ Tattoo Bob, Rotterdam

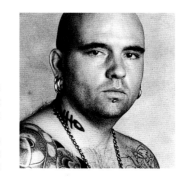

pages 30–31
Peggy and Mick
Ages 51 and 54
Housewife and retired

Artists: Jon Nott @
Trollspeil, Guildford
Pan Wilmott @
Trollspeil, Guildford

"I like the way it makes people look, but I get mostly good things said."

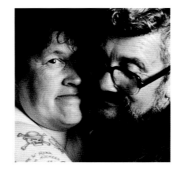

pages 32–33
Gertie
Age 44
Engineer

Artists: Filip Leu, Lausanne
Tommy @ East Side, Enschede
Rinto @ Tattoo Rinto, Groningen

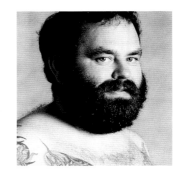

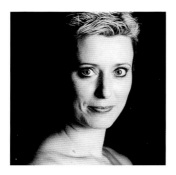

page 34
Fiona
Age not known
Piercer

Artists: Naresh @ Flamin' 8,
London
Cilla @ Original Skin, London
Jacqueline @ Triple X, Lucerne
Michelle @ On The Road
Yan Spencer @ Sacred Art, London

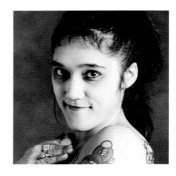

page 35
Patricia
Age 30
Slave-girl

Artist: Bianca Verwey @ Bianca's
Tattoo Solution, Hiluersum

7 6

pages 36–37
Alun
Age 28
Tattoo artist

Artists: Ian Barfoot, Reading
Ken Shercliff @ Midland Tattoo,
Cannock
Fiona Long @ Feline Tattoo,
Sheffield
Tom @ Silver Needles, Southend

page 39
Genea
Age 24
Works for a jewellery
piercing collection

Artist: Xed Le Hed, Brighton

"My first three tattoos were done when I was a lot younger and have now been covered up. I plan to have a lot more done."

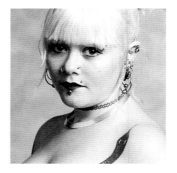

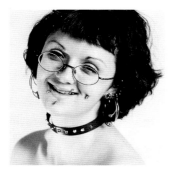

page 38
Bekki
Age 20
Body piercer's assistant

Artist: Woody, High Wycombe

"I love fairies and Woody drew me up a design. I absolutely loved it ... it's my one and only ... for now."

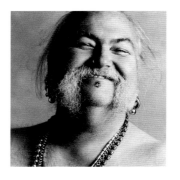

page 40
Mike the Buddha
Age 61
Tattooist

Artists: Nobi @ Tattoo Zone,
Stockholm
Peter Siwak, Nagdeburg
Snake, Gulti
X Tophe @ Tattoo Spirit, Bordeaux
and many others

"My first tattoo was a dragon."

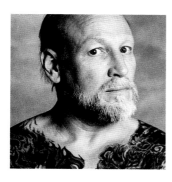

page 41
Nip
Age 46
Doorman

Artist: Trevor Marshel

The inspiration for the flames comes from a motorcycle accident in 1972 during which Nip's left foot was crushed. It has been burning ever since.

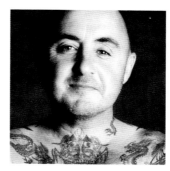

page 42–43
David (Bish)
Age 44
Labourer

Artist: John Tregarne @ Skin Creation, Cardiff

"I just like tattoos in general ... My first tattoo was a skull."

pages 44–45
Zoe
Age 26
Sculptor/Barmaid

Artist: Mo Back @ Evil from the Needle, London
Colin Stevens @ Ed Hardys, San Francisco
Kita @ Atomic Tattoo, LA
Dennis Cockle, London

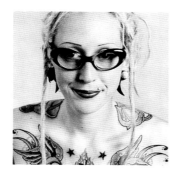

pages 46–47
Marius
Age 66
A former timber-merchant

Artists: Spider Web, USA
Ronald Bonkerk, Zaandam

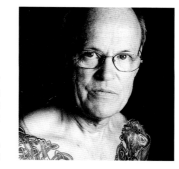

7 7

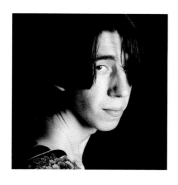

page 50
Andy
Age 20
Student

Artist: Lee Symonds @ Cherry Blossom Tattoo Studio, Walton-on-the-Naze

"I enjoyed being tattooed – it's all part of the art."

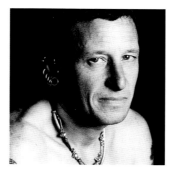

page 51
Nick
Age 36
Van driver

Artists: Andy Barber, Surrey
Teresa Gordon @ Taurus, Nottingham

pages 52–53
Michele
Age 36
Receptionist/Body Piercer

Artist: Graham Hodgson @ Crayford Tattoo, London

"The back piece is my favourite. I had it as it is a reminder of how I used to be."

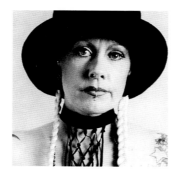

pages 54–55
Anna
Age 29
Postwoman

Artists: Lou @ Sacred Art, London
Jason @ Evil From the Needle, London

"Each of my tattoos is special and personal to me."

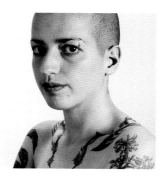

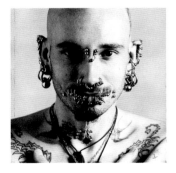

pages 56–57
Spud
Age 27
Warehouse Manager

Artists: Jo Harrison @ Modern
Body Art, Birmingham
Hagar @ Hagar Tattoo,
Birmingham

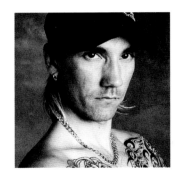

page 58
Gray
Age 30
Engineer

Artist: John Welburn, Hull

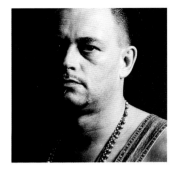

page 59
Jacky
Age 34
Tattoo artist

Artist: Roel Hekkers @ Golden
Needle, Anehem

**"I'm not religious, I just like
Jesus and crucifixes."**

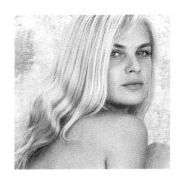

pages 60–61
Angie
Age 22
Cape Town

Artist: Hankie Pankie

7 8

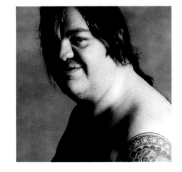

page 62
Terry
Age 44
Software consultant

Artist: Fiona Long, Sheffield

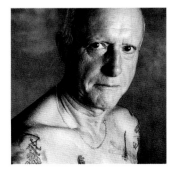

page 63
Michael
Age 62
Retired antiques dealer

Artist: Helter Scelter, Jersey

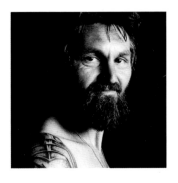

page 63
Simon
Age 44
Estate worker/gardener

Artist: Jon Nott @ Trollspiel,
Guildford

**"I always wanted to have a
dragon perched on my shoulder,
that's what started it all."**

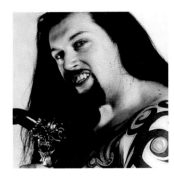

pages 64–65
Peter
Age 29
Miner

Artist: Chris Scott @ Custom
Tattoo, Leeds

Tattoos include an Indian armband
and The Cult rock band.

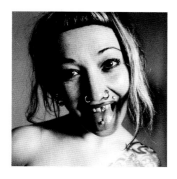

pages 66–67
Marlboro Mary
Age 33
Professional cider lush

Artists: Brent @ Viking, Dunstable
Alex Binny @ Into You, London
Michelle Edge @ Sacred Art, London

"Tattoos are addictive ... My
favourite tattoo is the next one."

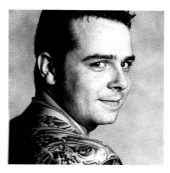

page 68
Paul
Age 23
Electronic Engineer

Artists: Steven Wrigley @ Irezumi,
Glasgow
Marco Bratt, Dunstable

"My favourite designs are on my
back. I am planning half sleeves
and chest."

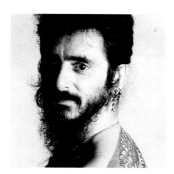

page 69
Mick
Age 45
Assembler

Artist: Jon Nott @ Trottspeil
Tattoo, Guildford

pages 70–71
Steven
Age 29
Tattoo Artist

Artists: Barry Saunders @ Saz's
Tattoo Studio, Warrington
Ken Cameron @ SBT, Miami

"I am a collection of tattoo
artists' work."

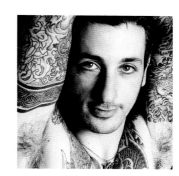

pages 72–73
Mark
Age 33
Lorry Driver

Artists: Warren Stares, Portsmouth
Graham Townsend

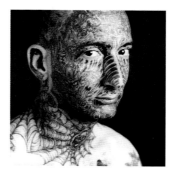

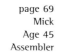

"It makes a joke of what is 'good' and 'bad' taste because
it transcends those redundant concepts by the investment of emotion ..."

Joolz, poet

7 9

ACKNOWLEDGEMENTS

I would like to thank Ian of Reading, tattooist (4 Chatham Street, Reading, Berkshire), and his crew for making the Dunstable Tattoo 1999 Expo possible; Mick Narborough (Skin Graphics Tattoo Art, 46 Avery Hill Road, London) for helping to get the project off the ground; Claudio Zeen for allowing us into his beautiful and unusual tattoo parlour (As 1 Am, 351 Kennington Lane, London); and Joolz for contributing her writing. Thanks also to Kodak Professional for E100VS; my close friend Astrid Garron in Donhead, Dorset, for being such an inspiration and for working on the introductory text with me; my two assistants, John Dickson and Karen Yeoman, for all their help and camaraderie; and to Elaine Partington at Eddison Sadd for asking me to do the project in the first place and supporting me throughout.

Finally, a big thank you to all the delightful people who appear in the book, for freely giving their time and their bodies and making the book what it is.
Dale Durfee

EDDISON SADD would like to thank Ann Kay and Ted Polhemus for their valuable assistance in preparing the 'Out of the Shadows' text, and Ian and Michelle of 'Creations', 51–53 South Street, Bishops Stortford, Herts, CM23 3AG for the loan of the chair seen on pages 38 and 64–65.

EDDISON•SADD EDITIONS
Commissioning Editor • Liz Wheeler
Editors • Nicola Hodgson and Ann Kay
Art Director • Elaine Partington
Designer • Brazzle Atkins
Production • Karyn Claridge and Charles James